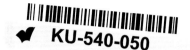
KU-540-050

Basic Digital Photography

A comprehensive, step-by-step guide
to selecting and using digital cameras,
computers, scanners and software.

Ron Eggers

AMHERST MEDIA, INC. ■ BUFFALO, NY

To Margo

Copyright ©2000 by Ron Eggers
All photographs by Ron Eggers, unless otherwise noted.
All rights reserved.

Published by:
Amherst Media, Inc.
P.O. Box 586
Buffalo, N.Y. 14226
Fax: 716-874-4508
www.AmherstMedia.com

Publisher: Craig Alesse
Senior Editor/Production Manager: Michelle Perkins
Assistant Editor: Matthew A. Kreib
Assistant Editor: Barbara Lynch-Johnt
Copy Editor: Paul Grant

ISBN: 1-58428-036-0
Library of Congress Card Catalog Number: 00-132631

Printed in United States of America.
10 9 8 7 6 5 4 3 2 1

No part of this publication may be reproduced, stored, or transmitted in any form or by any means, electronic, mechanical, photocopied, recorded or otherwise, without prior written consent from the publisher.

Notice of Disclaimer: The information contained in this book is based on the author's experience and opinions. The author and publisher will not be held liable for the use or misuse of the information in this book.

TABLE OF CONTENTS

PROLOGUE

With the availability of powerful (yet very inexpensive) equipment, digital imaging is becoming an option for almost any photographer. New computers, high resolution digital cameras, low-cost scanners that deliver professional results, and inkjet printers that can generate prints that look virtually indistinguishable from true photographs have made it easier to shoot a digital image, optimize it, print it, or distribute it electronically. As a result, digital photography is extremely accessible both for those doing it professionally, and for those who enjoy it as a hobby.

Higher resolution cameras, higher quality optics, increased zoom lens ranges, more precise auto-exposure and auto-focusing capabilities, expanded (and less expen-

"... digital imaging is becoming an option for almost any photographer."

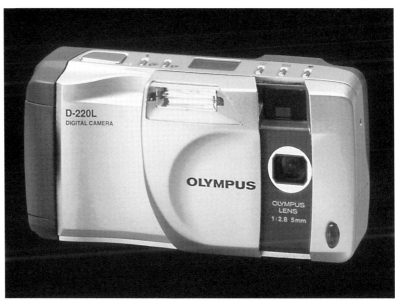

The increasingly high quality of digital cameras is one of the factors that has fueled the popularity of digital photography.

sive) storage options, enhanced bundled software for image transfer, manipulation and output, expanded output options (including the ability to print photos without having to go to a computer first), and significantly reduced price tags are all fueling digital imaging.

But digital imaging can be intimidating. Hopefully, this book will give readers who haven't been involved in photography before their start in digital imaging, and help those who have been involved in conventional photography make the transition from film to digital. It will also help photographers make the decision whether to go digital or not. Digital photography isn't for everybody, no more so than film photography is for everyone. Whether to go with digital technology or stay with film is very much a personal matter. Each photographer has to make up his or her own mind about that.

While there are specific sections detailing what to look for in digital equipment and information on how to use imaging software, the book isn't intended as a "how to" primer or as an equipment selection guide. It's designed, instead, to give readers a good understanding of the fundamentals of digital imaging, its history, its development, and its terminology.

Digital imaging technology is changing so quickly that it's difficult to keep up with specific products and model types. There are new digital cameras, scanners and printers coming out all the time. For example, a camera company might release three or four new models within a year. The information that's included here should make it easier for readers to select the right camera equipment, computer hardware and software programs to meet their specific needs, regardless of when they're making their decision, and then help them use it effectively.

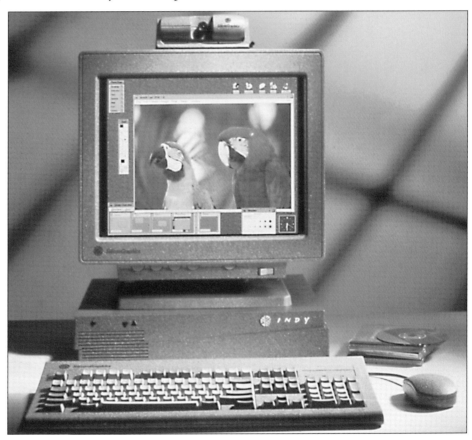

Enhanced hardware and software options have made digital photography increasingly versatile.

1

INTRODUCTION TO DIGITAL IMAGING

There are advantages and disadvantages for both film and digital photography. Conventional camera gear is still less expensive than digital camera gear. Even very sophisticated film cameras cost only a fraction of what digital cameras with similar capabilities cost. For the next few years, for the most part, even with sophisticated digital cameras, the quality of photographs captured on film will still be higher than the quality of photographs captured digitally.

On the other hand, the quality of photographs captured digitally is getting better all the time. The difference between the images that could have been captured with consumer digital cameras a few years ago and those that can be captured now is tremendous. Digital technology is certainly good enough for many applications.

Another advantage of digital technology is that film, which can get expensive, is not involved. Once the investment in cameras and imaging equipment has been made, there's no need for film or processing. That can mean a tremendous savings over a period of time. Digital imaging also makes it a lot easier to work with images than conventional film, processing and printing. Specialized photographic techniques that might have taken extensive expertise to do in the darkroom can, with the right hardware and software, easily be done by the average computer user.

"Digital imaging makes it a lot easier to work with images..."

● The History of Photography

To understand digital imaging, it's a good idea to know a little about the background of photography in general and electronic photography in particular. While there is some debate over who actually took the very first photo-

graph, that honor is generally credited to Louis Jacques Mande Daguerre. In the early 1830s, his daguerreotype changed the way images were saved for posterity. All of a sudden, it became possible for even the least artistic person to accurately depict a scene by capturing it as a latent image. That was revolutionary, but initially, photography wasn't really looked upon as much more than a tool to help painters freeze a moment in time. With photography, a model wouldn't have to spend hours and hours posing. Similarly, the changing shadows of the day wouldn't destroy a landscape composition.

It didn't take long, however, for photographers to realize just how powerful a medium they were working with. And it didn't take long for them to value the photographs that they were taking as works of art in their own right. Developments in photography continued during the second half of the 19th century. One of the most notable ones was the transition from wet plate to film negatives. The wet plate process required transporting a portable darkroom wherever the shot was taken, so that it could be processed before the light-sensitive material on the plate dried up. At that point, the image would be lost. Each photo plate had to be individually coated, shot and processed in rapid succession.

> **TERMS TO KNOW:**
> A **latent image** is one that is recorded, but can't be seen until the film is processed.

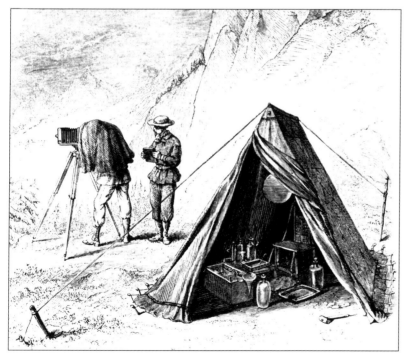

In the Old West, photographers had to take a full darkroom set-up along with them.

The introduction of dry light-sensitive material made it possible to shoot a series of photographs simply by switching one coated glass plate for another one. Once exposed, the plate could be carried for extended periods of time

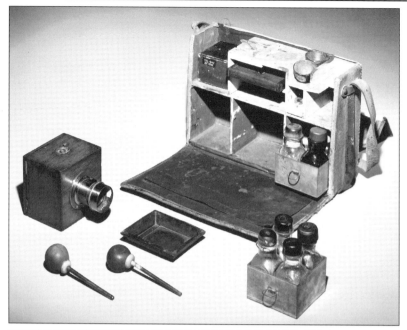

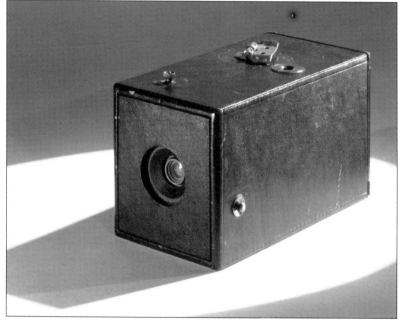

before it had to be processed. That freed photographers from the need to bring along a dark-room. The late 1800s saw the advent of consumer photography with the introduction of the Original Kodak Camera.

In 1900, George Eastman took one step further with the first Brownie. Until that time, taking a photograph required a tremendous amount of technical skill, endless patience and a considerable amount of money. With the Brownie, which cost a mere $1, anyone could take photographs. Even people with very little patience, limited funds and no technical expertise could take competent shots.

It was simply a matter of buying a box camera, preloaded with film, taking the pictures, sending the camera with film back to Kodak, and receiving the processed negatives, the prints and the reloaded camera back from the company. It couldn't have been easier. If the photographer wanted it, Kodak would even print the photos on post card stock, making it easy for people to send their photographs to friends, relatives and associates.

Once people were able to take their own pictures, photography as a whole exploded. People started using photography for all sorts of things that it had never been used for before, including family

(Top) An early portable processing lab. (Center) One of the original Number 1 Eastman Kodak cameras (1888). (Bottom) A roll of Kodak film. The introduction of roll film changed photography.

photos, business applications and professional purposes. Millions and millions of shots were taken, and many of those were mailed around the world. It was akin to what is happening with digital images today.

● The Birth of Digital Imaging

Digital imaging is having a tremendous impact on photography—as much as, if not more than, the transition from the wet plate to dry process and the introduction of roll film for consumers. It is opening up a whole new world of picture-taking, and consumers are taking to it very quickly. Just as the wet plate process freed photographers from having a darkroom with them, digital imaging is freeing photographers from using a darkroom at all. It is, in effect, liberating them. With digital imaging, it's possible to take high quality photographs, electronically download them to a computer, manipulate and optimize them, and print them out. That can all be done without ever having to take anything to a lab or processing facility; without having to spend any time standing over caustic chemicals in a little room (usually a large closet or spare bathroom for most amateur photographers) with a red light on.

The quality that can be achieved, even with relatively inexpensive digital cameras and low-priced photo-realistic printers, is amazing. It's close to rivaling output produced by photo labs. While prices for digital cameras are still higher than conventional film cameras, they are going down all the time. In fact, there are already some models available that cost less than $100, and that includes the camera and bundled software applications.

There's a misconception that digital imaging is something new. It is true that it's only been available for consumers since the mid-1990s, but it has actually been around for some thirty years. Digital imaging was developed for the U.S. space program. NASA needed a reliable way to get photographs back from spacecraft that were heading into deep space, never to return to Earth. What the Jet Propulsion Laboratory (JPL) in Pasadena, California (the NASA facility responsible for deep space imaging) came up with was a way to take a photograph, turn it into a series of individual picture elements (where the term "pixel" came from)—a number value

TERMS TO KNOW:
Downloading means to transfer a digital file to a computer's hard drive from another source (a digital camera, the Internet, etc.).

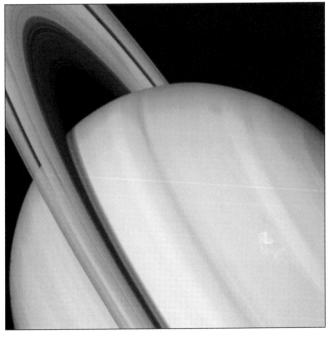

Saturn, captured digitally from a space probe.

JPL pioneered digital imaging with its early images of space.

TERMS TO KNOW:

A **pixel** is the smallest information-containing unit in a digital image. The term is derived from "picture" and "element."

Grayscale is the digital imaging term for a black and white image.

based on the light intensity of that point on the picture—and transmit that number back to JPL.

Those first digitized images were in black and white (called "grayscale" in imaging terms). They broke the scenes captured by the camera on board the spacecraft down into rows of dots 800 across and 800 down, for a total of 640,000 individual pixels. Each individual dot was assigned a number from 0 to 255, corresponding to the intensity of the light at that position. That number could be easily transmitted back to Earth in a data stream from the spacecraft.

At JPL, the pixels in the data stream were recombined in the correct order, in effect recreating the photo that was taken. It was a quick, effective, and accurate way of transmitting images across the void of deep space. As JPL perfected its techniques, higher pixel counts, the addition of RGB (red, green, blue) filters on spacecraft cameras, and triple exposures made it possible to shoot full color images.

By the early 1980s, companies began to see the value of digital imaging for commercial applications. They realized

that by changing some of the values of the individual pixels, they could easily change the characteristics of parts of an image. At the time, several multimillion dollar systems became available that could do such revolutionary things as change the color of a model's hair or eyes. Corporate graphic departments, ad agencies and photographers would rent time on these systems for as much as $5,000 a day to do such things as change the color of a pair of jeans from blue to red.

Throughout the 1980s, digital imaging systems were very expensive. On the editorial side, publications with big budgets, like *National Geographic*, started using digital imaging systems to manipulate their images. One of the best known stories about the early days of digital imaging was a cover shot that *National Geographic* was running of the pyramids in Egypt. They turned a horizontal shot into a vertical one, so that it would fit onto the cover—by moving the pyramids just a little closer together.

Their rationale was that, if the photographer had known that that shot was going to be considered for the cover, he would have shot it vertically. He could have had the pyramids a little closer together simply by moving a few steps to one side. All that was being done on the system was something that the photographer could have done, so it was

By the mid-1980s, digital imaging was going mainstream and extremely expensive systems were installed by many commercial labs and service bureaus. These systems were often obsolete before the last payment was made.

okay to change a photograph like that. Some people questioned that rationale, but the cover ran.

By the mid-1980s, digital imaging was going mainstream. Extremely expensive systems were being installed at commercial photo labs and service bureaus. It was quite common for a lab interested in getting into digital imaging to spend $2 or $3 million dollars on a system, and contract to pay it off in five or seven years. Frequently, before the system was even paid off, technology advanced so rapidly that the equipment didn't have more than salvage value. By the early 1990s, there were fully configured digital imaging systems available for $50,000 that could run rings around the multimillion-dollar equipment.

For general use, the first electronic still photography cameras weren't digital. Rather, they were still analog video frame capture devices. Sony made a big splash with its Mavica line, which was targeted at professional applications. Canon had a still video camera for consumers. When those systems were used correctly, the results were actually quite good. Unfortunately, getting good results required expertise, so analog still imaging fell out of favor relatively quickly—with digital technology filling the void.

The old adage in the computer industry is that processing power doubles every eighteen months, while the price is cut in half during that same time period. In digital imaging, at least, that's proving to be pretty accurate. Processing power has increased incredibly. Desktop computer systems designed for digital imaging are rapidly approach a 1,000 MHz clock speed. Compare that to 4.77 MHz for the original PC and 8MHz for the XT model, which was the first PC to come preconfigured with some graphic capabilities.

At the same time that performance has climbed, prices of computer equipment have dropped like rocks. In the early days of personal computing, when the IBM PC reached the market, 10 megabyte (MB) hard drives cost around $2,000, or $200 per megabyte of storage capacity. As late as the early 1990s, a 500MB hard drive cost about $2,000, or about $4 per megabyte. That's a significant drop in price, but not anywhere as significant as the more recent drop in prices. There are now 20 gigabyte hard drives available for less than $200—a mere penny per megabyte.

Although not quite as dramatic, there have also been major price drops in memory. I had to pay almost $2000 in the early 1990s to add 32MB of memory to my 386-based

TERMS TO KNOW:
The **processing power** of a computer measures how quickly a computer can perform calculations (and therefore process information). It is measured in megahertz (MHz).

The **hard drive** is a digital storage unit where user files, applications, etc. are stored on a computer. New files can be added (or deleted) as the user desires.

Memory (or RAM) is the computer's internal memory which it uses to complete tasks (such as running software). Increasing the memory of a computer can increase its speed, allowing your programs to run more quickly, and making it possible to run more applications simultaneously.

Compaq Deskpro. Memory is now around $1 and $2 per megabyte.

There are now entry-level digital imaging systems that professional photographers and graphic designers would have killed for—even in the mid-1990s. While good consumer-oriented digital imaging systems can still cost anywhere from $1,200 to $1,500, there are now some computer systems available for $300 (even less with the various rebates that manufacturers and on-line services are providing).

The Potentials of Digital Imaging

Conventional film photography is sometimes called latent imaging. In other words, the image that's stored on the film can only be seen once the film has been processed. If the film is pulled out of the camera, nothing can be seen on the film before it's processed. In fact, the film would be ruined and the latent images would be lost if the film was exposed to light.

Any photographer that has spent any time in a darkroom knows how difficult it can be to process and print film correctly. The chemicals are caustic. When being prepared for processing, the film itself can't be exposed to light at all, not even momentarily, not even to red "safe" light. Any error and the film is irreparably damaged—possibly even ruined.

All printing has to be done under a "safe" light or else the paper would go dark. It's a trial and error process that can be time-consuming and expensive if it isn't done right. Darkroom work can be very challenging, and it can be very rewarding. But it can also be very frustrating, and, at times, disappointing. Every photographer who's ruined an important roll of film can attest to that.

With digital imaging, there's no need to try and try again to print that perfect photo in the darkroom. In fact, there's no darkroom required at all. Many inexpensive computer printers can produce prints that look much like photographs. The fact is, because of how easily things can be accomplished, and the wide variety of products that can be achieved, the potentials of digital imaging are almost unlimited.

"... the potentials of digital imaging are almost unlimited."

Equipment Selection

Most photography is "application specific," which means that the type of equipment selected depends upon what's going to be done with it. A photographer who's

going to shoot a glamour ad in a studio has totally different equipment needs than a newspaper photographer who is going out to cover some breaking event. The newspaper photographer also has different equipment needs than the father who wants to shoot his daughter's fifth birthday party.

Digital equipment is even more "application specific" than conventional photography. There are different digital cameras available for in-studio portraits and in-studio still lifes. Some digital cameras work very well for snap-shooting, others don't. Some have commercial applications, while others in the same price range may not. There are film and transparency scanners, flatbed scanners, document scanners and various other options to digitize images. Computer systems ranging from palmtops to massive workstations are available. On the output side, there are various types of technologies in different output sizes.

This means that, in digital imaging, it is especially important to match equipment to job requirements.

Each step of the digital imaging process is important. Deciding what type of equipment to buy and how it should be configured depends upon what the photographs are

Film scanners are one type of input device for digital imaging.

going to be used for. As with computer equipment in general, it's possible to spend as much as you want to on digital imaging equipment. If you have the budget and can justify the need, you can spend tens of thousands of dollars and more to get into digital imaging.

The best way to approach buying digital equipment is to figure out its primary purpose before buying, then investigate the models that best meet those needs. Certainly, once purchased, the equipment can be used for things other than the primary purpose, but at least you know that it will meet the most important requirements.

The equipment required for digital imaging can be broken down into four broad-based categories: input devices; computers; software programs, and output devices.

Primary input devices are the digital cameras and scanners. They can be used to turn photographs, negatives and transparencies into a digital format, which can be manipulated electronically. Other image sources include CDs and the Internet, but they generally aren't considered input devices.

A computer and software are required to manipulate digitized shots.

Once the shots have been modified and optimized, there has to be a way to do something with those images. That could mean an output device, usually a printer, but it could also be a film recorder. Images can also be distributed electronically on the Internet.

> **FACTS TO NOTE:**
> The equipment required for digital imaging can be broken down into four categories:
> 1. Input devices
> 2. Computers
> 3. Software programs
> 4. Output devices

Photo CDs, with professional scans from negatives, slides, or prints can be used to get images onto a computer.

Digital images can be created, optimized and modified to yield high-quality final images, such as those above.

Digital photographs are simple to send to friends and family via the Internet, making it easy to keep everyone up to date on your latest vacation or how the kids are doing.

2

DIGITAL CAMERAS

One of the first pieces of equipment that most photographers buy when they get into digital imaging is a digital camera. Since you often get only one chance to capture an image, it's important to make sure that the camera does it right. Selecting a digital camera is a subjective process, and styles and features are always changing. What one person might find appealing or essential could be of little value or interest to someone else. Because digital cameras are so different, and everybody has different requirements, much of the section on input devices is devoted specifically to them. In this chapter, the general history, basic components and common operations are discussed.

● Market Segments (Amateur to Professional)

Commercial digital cameras haven't been around quite as long as commercial digital imaging. Most people think that digital imaging started with the introduction of consumer digital cameras. It makes sense, since that's when they were first made aware of it. While there have been some digital cameras on the market for almost a decade, it wasn't until the mid-1990s that the quality of the images that they captured met commercial and professional requirements. Even then, though, image quality still didn't match photos taken on film.

Image quality has improved significantly over the last few years. There are professional-level digital cameras that can capture images that match those taken with film. Almost all newer digital cameras have multiple shooting modes, including a burst shooting setting (which is similar to a motor drive mode on a 35mm camera), multiple

"... there have been some digital cameras on the market for almost a decade..."

metering modes for highly accurate light measurements, and multiple flash modes with red-eye reduction. Once taken, shots can usually be stored at various resolutions, different compression levels and varying image qualities.

Until relatively recently, digital camera manufacturers broke markets down into two segments: professional and consumer. Probably the earliest commercial use of digital cameras was on the commercial side for shooting still lifes. Without any subject movement, it was possible to make three consecutive red, green and blue filtered exposures. Some of the earliest users of digital cameras in the field were news photographers. Photojournalists were amazed at being able to take a picture, store it electronically and transmit it over normal phone lines. But those early digital cameras were bulky devices that not only required camera and related electronics, but also a special portable hard drive that was larger than a VCR. Besides being bulky, they were also expensive—$20,000 to $30,000 and more.

Many of the early advances in digital cameras were made at the professional level. Successful professional photographers are much more likely to invest in emerging digital imaging technology than consumers. Indeed, digital imaging equipment proved to be very profitable for manufacturers. Some studio cameras and specialty backs for medium and large format cameras cost as much as $60,000. This meant that a company didn't have to sell a lot of units to make a good profit. When they first reached the market, such high-priced cameras were worth it because they cut film and processing costs, reduced turn-around time and simplified image optimization. The high quality and resolution of the shots these cameras took could be used for many of the same applications that film photos could be.

Digital cameras targeted at consumers have been around since the early 1990s. They were still more expensive than film cameras with similar capabilities—sometimes eight to ten times as much—but they were much more affordable than professional cameras. With any technology, there are always what are called "early adapters," people who try equipment before it's proven or becomes popular. The experience these "early adapters" have with that equipment frequently determines how quickly that technology becomes widely used.

Unfortunately, early experience with consumer digital cameras proved to be less than optimal. Resolutions were extremely low, the quality of the images was marginal, the storage capacities limited, and the battery life totally unac-

> **FACTS TO NOTE:**
> Digital cameras targeted at consumers have been around since the early 1990s.

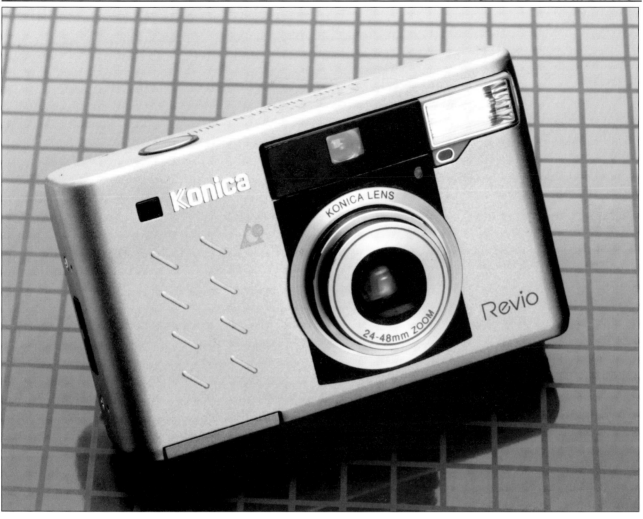

A consumer model digital camera.

ceptable. As a result, their reputation suffered. The problems with early consumer digital cameras probably did more to turn people off to digital imaging than any other thing—except maybe the price. It wasn't until 1996 or 1997 that the quality of the images captured with consumer digital cameras was high enough even for most casual applications. In spite of their shortcomings, some consumers liked them. They reduced film and processing costs, and also made it possible to accomplish things that couldn't be done with conventional photography. Even with all the problems, some photographers recognized the potential, and saw the future of photography in it.

There is a new market segment developing somewhere between lower-end professional digital photography and higher-end consumer digital imaging that will become increasingly important over the next few years—the business-imaging segment. There are a number of developments that are driving the business use of digital technology, which is quickly becoming the largest market segment for digitals. The higher image quality and higher resolution

of pictures that can be taken by digital cameras, and their reduced price tags, have made them well suited for business use. Both business and professional photography may be used for commerce, but the requirements for both types of applications are quite different.

Business digital camera.

When shooting professionally, the quality and style of the shot being taken is often as important as the image content or subject matter. That's generally not the case in business photography. With business digital imaging, the primary requirement is to get good quality shots. Businesses need to take large numbers of what might be called "record" shots. Insurance companies, real estate firms, medical offices, and a wide variety of other businesses are turning to digital to get those shots, and, at the same time, reduce film and processing costs, streamline record keeping and simplify operations.

It's very easy for an auto insurance firm, for example, to have its adjusters shoot digital images of insured vehicles involved in accidents, transfer them to a laptop, transmit them by way of a cellular phone modem to a centralized location, incorporate them into a database, and distribute them to whoever might need them to handle the claim.

The emergence of the business market is affecting all digital imaging. It will continue to bring prices down, as the number of units that are being sold into that market continues to climb. It will increase the capabilities of all

FACTS TO NOTE:
Digital cameras have become increasingly useful business tools in fields (such as insurance and real estate) where a large number of "record" shots are needed.

digital cameras as the various imaging capabilities that corporate imaging departments need migrate to the consumer level.

● Image Storage Components and Capabilities

All cameras, whether they're conventional cameras or digital models, have certain components. For example, all cameras have some way to capture and retain the images that they take. For conventional cameras, images are stored on film. For digital cameras, images are either stored in internal memory or on removable media cards.

With both film and digital cameras, the larger the captured image, the better the image reproduction. For film cameras, that means larger film sizes. There have been 8mm still cameras and cameras that used very small disc negatives, but the smallest widely available film was 110. This small format provided acceptable results for snapshots, but not much else. The originals generally weren't acceptable for enlargements or publications. For the most part, with some notable exceptions (such as a 110 SLR by Pentax), the cameras that used 110 film were relatively unsophisticated—usually point-and-shoot models.

The 110 film format isn't used much anymore. It has been replaced by the Advanced Photo System (APS) film

APS film camera.

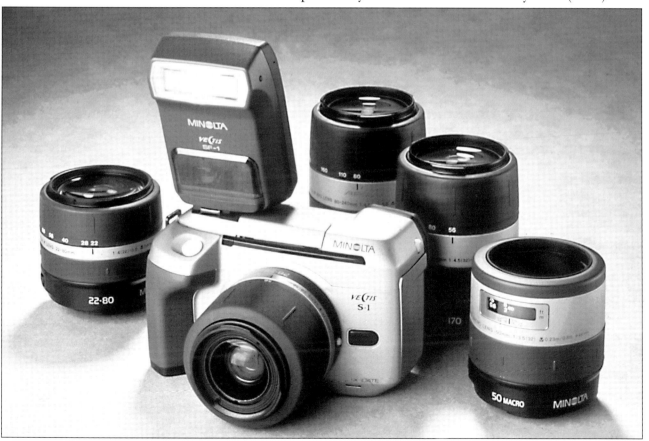

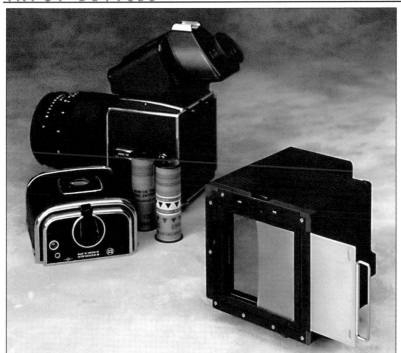

Medium format camera with a digital capture unit.

format for consumer photography. With APS, the film size is larger, the quality of the images is better and the equipment is much more sophisticated. While it isn't generally referred to as such, APS film is 24mm film, which results in negatives about two-thirds the size of standard 35mm film. The image quality of APS is good—very good, in fact.

The best all-around film format (used extensively by hobbyists, photojournalists, art photographers, corporate photographers and even many commercial and studio photographers) is 35mm. It provides an ideal combination of affordability and image quality.

Beyond that, there's medium format film (sometimes called 2¼" or 6cm x 7cm) and large format (also called 4" x 5") film. But those films are too expensive for all but the most serious photographers.

This is not a book about film photography, but understanding the different film sizes will help you to understand digital camera image capture capabilities. Instead of film, digital cameras capture their images on charge couple devices (CCD). There's a certain correlation between film sizes and CCD sizes. For now, virtually all digital CCDs, even the ones in the least expensive cameras nowadays, capture images at full 24-bit (sometimes called true) color. Some cameras do have special monochrome (black and white) and sepia tone shooting modes.

Like film, CCDs come in various sizes. Instead of being measured by their size, CCDs are measured by resolution. The larger the CCD, the higher the resolution. Most peo-

FACTS TO NOTE:
There are other ways digital cameras capture digital images besides CCDs—primarily CMOS sensors. CMOS technology has actually been around for quite some time, but technical difficulties have kept it out of the mainstream of digital imaging. If those technical difficulties are overcome, CMOS technology may become important in the years ahead. For the foreseeable future, though, it will represent only a small fraction of the overall digital cameras on the market.

TERMS TO KNOW:
The **resolution** of an image is the number of pixels per inch. The higher the resolution, the more information (pixels) is included in every area of the photograph, and the higher the image quality. Higer resolutions also, however, result in larger files which require more memory to store and process.

ple who buy digital cameras don't realize that the CCDs for cameras that have resolutions of less than one megapixel (in other words, one million pixels) are about the same size or smaller as negatives taken with 110 film. That explains why image quality is sometimes less than acceptable. Some photographers buy such digital cameras, which can be priced several times higher than 35mm film cameras, and find out that their pictures don't look much better than shots taken with a 110. Even the shots taken with more expensive digital cameras, with all the technical bells and whistles that any gadget freak might want, can be of marginal quality if the CCD isn't large enough and the resolution isn't high enough.

Most of these lower-resolution digital cameras are about the size of miniature auto-focus/auto-exposure clamshell film cameras. Because of the huge number of them on the market, the smaller CCD, smaller resolution, lower-priced digital cameras are the biggest sellers. There are dozens and dozens of models, ranging from very simple point-and-shoot units with preset focus and exposure, to relatively sophisticated cameras with multi-mode metering and exposure capabilities. For most of these models, the resolution is anywhere from basic screen resolution (640 x 480 pixels) to around one megapixel.

Newer digitals have CCDs that are somewhat larger; so image quality is better. In overall body size, they're not much larger than the lower-resolution models, but the

A miniature digital camera.

quality of the images is considerably higher. For these cameras, the resolution is somewhere between one and two megapixels.

Resolutions for some models in this category can be misleading, however. Sometimes both an optical and a maximum resolution are cited by the manufacturer. The maximum resolution is usually listed as twenty or thirty percent higher than the optical resolution captured by the camera. To achieve this higher number, the resolution of the captured images is automatically increased (or interpolated up) by software as the shots are transferred from the camera to the computer. Comparisons should be based on optical, not interpolated, resolutions.

Almost all of these cameras have very sophisticated image capture, manipulation and transfer capabilities. That makes them particularly well suited for business applications.

New digital camera model.

● SLR Digital Cameras

The next category of digital cameras is the single lens reflex (SLR) models, which are available in both APS- and 35mm-body formats.

APS-Size Systems. Digital SLR cameras the size of APS cameras usually have two to three megapixel CCDs with advanced exposure and focusing controls. Their CCDs aren't quite as large as individual APS frames, but CCD sizes for that format are getting closer. These digital cameras have some professional capabilities, but are still priced within the reach of many consumers. They're a good choice for photographers who have the need for both film and digital image capture and want to be able to use the same interchangeable lenses and other system components for film photography and digital imaging, but don't need highly sophisticated professional camera systems.

35mm-Size Systems. If the objective is professional-level imaging, then a digital 35mm system camera is the way to go. Again, CCD sizes don't precisely match 35mm frame size. They can have CCDs anywhere from two megapixels to six megapixels, but with image quality being extremely high. The digitals in 35mm bodies have all the functions and capabilities, take all the lenses, and work with all the accessories of equivalent model 35mm film cameras.

35mm-type digital camera.

Eastman Kodak, for example, makes 35mm-type digital cameras based on both Canon and Nikon systems, making it easy to find a digital body that fits into a system. With rather steep price tags, these cameras are primarily for professionals.

There are also medium and large format digital cameras available, but the high cost of these models places them beyond the range of most photographers (even most professionals) and beyond the coverage of this book.

● Lenses

All cameras have lenses. The type and quality of lenses may differ (some are glass and some are plastic), but all cameras need some way to focus the light onto the film or digital CCD plane. Camera lenses are designed with multiple lens elements arranged into groups. Usually, the more lens elements, and the more groups, the higher the quality of image that the lens can take. The only reason that's even mentioned is that interchangeable lenses have more elements and groups in them (and tend to be of higher quality) than fixed lenses built into cameras. The ability to use those lenses with digital equipment can make a difference in image quality.

Focal Lengths. Focal lengths for digital camera lenses can be misleading. Lenses for digital cameras are frequently rated in what's called "35mm equivalency," even for those models that don't look like 35mm cameras. What that means is that the focal length of the lens covers approximately the same range as a 35mm format lens would cover. For example, many smaller digitals say they have a "35mm-110mm equivalent" lens. The reality is that, with a small CCD, the lens might only have a focal range of 7mm-22mm, but the coverage, in relationship to the size of the CCD, would be equivalent to the moderately wide-angle to somewhat telephoto coverage of 35mm-110mm zoom lenses on 35mm film cameras.

Another difference between conventional camera optics and digital camera optics is that with digital camera optics, the zoom range can be enhanced digitally. Many camera manufacturers say their digitals have a 6x, 8x, or wider zoom range. If you read the fine print, though, that zoom range is achieved through a combination of optical and digital zooms. A camera with a 6x zoom might have a "2x optical/3x digital" zoom. What that means is that the lens provides 2x magnification, which the camera then blows up three times to attain maximum zoom.

> **TERMS TO KNOW:**
> The **focal length** of a lens determines the magnification of images taken with that lens. The longer the focal length, the larger the magnification.
>
> A **zoom lens** is a lens with multiple focal lengths, making it possible to reduce or increase magnification without switching lenses or changing camera position. Digital cameras often offer an additional "digital" zoom feature that enlarges the image beyond the optical range of the lens.

While it's sometimes nice to be able to get really close to a subject with the digital zoom, digital cameras should be compared and judged by their optical zoom capabilities. Since digital zooms actually enlarge part of the captured image, they can easily enlarge image defects. If a shot is really important and requires going in tight, it's best to shoot it at the maximum optical zoom setting. With earlier camera models, if you didn't know what to look for, it was difficult to tell whether the camera was zooming in optically or digitally. More and more, cameras now make it possible to set digital zoom separately from optical zoom, for much greater photographic control.

Aperture Control. Another element common to all cameras is the lens opening, or f-stop, control. That's the aperture setting, which, with film cameras, is usually controlled by a ring or other adjustment on the lens itself. On digital cameras it's usually just another option on the main or sub-menu. The lower the f-stop number, the more light a lens lets in. Each full f-stop lets in about twice as much light as the next smaller one, and half as much as the next larger one. This means that an f11 aperture lets in roughly twice as much light as f16, and about half as much f8.

Even with older film cameras, it was possible to set f-stops in fractional increments to come up with exactly the right exposure. In the automatic shooting mode, digital cameras have an infinite number of aperture possibilities. In the manual shooting mode, they can generally be adjusted in third- or half-stops.

Lens Speed. The maximum amount of light a lens lets in is its speed. The faster the lens, the more light is let in, and the lower the light level that's required to come up with acceptable shots. Digital cameras don't have particularly fast lenses, but they don't really need them. CCD light sensitivity is better than the light sensitivity of most commercial films. Increasingly, digital cameras have a wider dynamic range than film, making it possible to shoot as easily in bright sunlight as in a dimly lit room. (That's not to say that film can't be used to shoot such situations; it's just that, to do so, it takes special film, a tripod, and a certain amount of expertise.)

● Shutters

All cameras also need some form of shutter. Film cameras have either focal plane shutters, which move across the plane of the film frame at the rear of the camera, or compur shutters, which are circular shutters that are generally

TERMS TO KNOW:

The **aperture** is the lens opening through which light passes into the camera to make an image.

An **f-stop** is an aperture setting that changes the amount of light passing through the lens by a factor of two (or one half).

The **lens speed** is the maximum amount of light a lens will let in.

The **shutter** is a device that controls the duration of time during which light is allowed to enter the camera to make an image.

part of the lens mechanism. Digital cameras use electronic shutters. Older film cameras with mechanically controlled shutters could be set at eight or nine different shutter speeds, generally ranging from "B" for bulb (or extended) exposure to 1/1000 of a second. Unlike with f-stops, which could be set at in-between settings, for most models, shutter speeds had to be adjusted to specific settings. As with f-stops, each shutter setting lets in roughly half or double the amount of light of the adjacent setting. A shutter speed of 1/125 of a second lets in twice as much light as a shutter speed of 1/250 of second, while it only lets in half as much light as 1/60 of a second.

Older 35mm mechanical cameras.

Theoretically, newer electronically controlled film cameras have an unlimited number of shutter speeds, since their built-in microprocessor can trip the shutters for exactly the right length of time that's required for an exposure. That's also the case with digital cameras. Most of them don't even have a separate shutter speed adjustment; the camera does it all. Higher-end cameras that do have some manual capabilities or exposure overrides usually group shutter control into the main camera settings menu. The vast majority of casual digital photography is done while cameras are set on automatic, but there are times when it's nice to be able to control shutter speeds. For example, slower shutter speeds make it possible to select longer exposures in order to create special blurring effects, while faster shutter speeds can be used to freeze action.

"... there are times when it's nice to be able to control shutter speeds."

● Viewfinders

In order to take a picture, you have to have some way of framing it. With inexpensive cameras, it's usually a viewfinder, which is basically just a glass window in the body that approximates the lens magnification and film frame dimensions. Somewhat more expensive cameras utilize a rangefinder framing and focusing mechanism. Rangefinders are also a glass window, but, besides the primary image in that window, there's also a smaller, secondary, transparent image in the window. By turning the focus-

ing ring on the lens, the secondary image moves. Focusing is done by matching the secondary image with the primary image. On more expensive rangefinders, the lens and rangefinder are coupled, meaning that the magnification of the lens and the rangefinder match, making the size of the image in the rangefinder match the size of the image in the lens. The image in the rangefinder window isn't the exact same one that's seen by the lens, but it's relatively close.

The lowest-priced digital cameras have preset focusing and simple viewfinders. Somewhat more expensive digitals have viewfinders with an autofocus lens mechanism. Even more expensive digitals have both a coupled viewfinder, like the coupled rangefinders of film cameras, and a separate color liquid crystal display (LCD). Either the viewfinder or the LCD can be used to frame a shot. The image in the LCD is exactly the image that's captured on the CCD, except that the LCD version is lower resolution than the image that will be captured by the CCD. Once taken, the image momentarily freezes on the LCD screen. The LCD can also be used to view images stored on the internal or removable memory, either individually or in a group.

Whether film or digital, most higher-end electronic cameras have autofocus capabilities, letting the photographer concentrate on framing. With most digitals, manual focus is the exception. It's available on some cameras that offer manual creative controls. But manual focus on digitals, even higher-end digitals, works more like the manual focus on inexpensive 35mm cameras, which requires estimating distances and ranges.

Single lens reflex cameras handle focusing and framing through the same lens that puts the image onto the film or CCD. The image that's seen through the viewfinder is exactly the same image that's captured. Most SLRs have both manual and autofocus capabilities. Higher-end SLRs have extremely sophisticated autofocusing.

FACTS TO NOTE:
With the exception of SLR systems, relatively few digital cameras offer a manual focus option.

● Power Supply

Most older film cameras are mechanical cameras. Some cameras have both mechanical and electronic components. The shutter and aperture might be mechanical, while the exposure meter is electronic. Not all cameras require a power source. Whether viewfinder, rangefinder or SLR, mechanical cameras without any type of light metering capabilities don't require any power, while mechanical cameras with metering capabilities require some sort of power. On some models it's a solar cell, while on others it's a small

battery. The only thing that power is there for is to make exposure readings. All the settings have to be made by the photographer. The advantage of most mechanical cameras is that they can still be used when the power fails. The light meter might not work, but the picture can still be taken.

Electronic film cameras, with features like autofocus and automatic film advance, require a power source to operate.

Electronic film cameras with features like auto-focus, auto-exposure, and automatic film advance and rewind require power. With consumer cameras, that might be a small 3-volt or 6-volt lithium battery, or maybe even a rechargeable nickel cadmium (NiCad) battery. Professional cameras require as much as 12 volts of power, with many of them having rapid recharging capabilities. For many of these types of cameras, when the power fails, picture taking stops.

That's also the case with digital cameras. A few years ago a reader of one of my digital camera reviews, which mentioned power problems with a specific model, e-mailed me saying that he wished he had read that article before buying the camera that he did. He was taking pictures with his new digital camera for a shoe catalogue he was producing, and had to use 83 sets of AA batteries to get 100 pictures. It's a lot better now than it was a few years ago, but power is still a consideration. Every feature and function of a digital camera requires power. Without it, nothing works.

With most models, power is sucked out of batteries. Most consumer digital cameras use four AA batteries, which can be disposable or rechargeable. Special alkaline photo batteries are available with an optimized discharge characteristic, providing the peak power per discharge digital cameras need to work correctly. There are also some

"Every feature and function of a digital camera requires power."

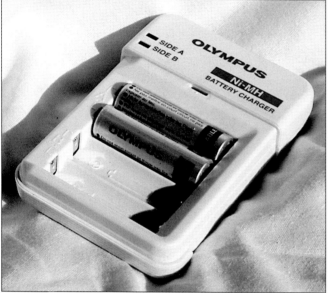

(Top) For 6-volt batteries, lithiums are the best choice. (Bottom) Nickel metal hydride (NiMH) batteries are a better choice than NiCad batteries for rechargeables.

digitals that use 6-volt batteries. For those, lithiums are the best choice when it comes to disposable power sources.

As far as rechargeables, most people are familiar with NiCad batteries, but they're not the best for digitals. Nickel metal hydride (NiMH) batteries are the best rechargeables available. Many of the higher-end digitals ship with four NiMH batteries and a small wall charger. It's a good idea to get an extra set or two of the batteries. It's guaranteed that you're going to need them at some time or another—more than likely when taking some very important pictures.

While NiMH batteries have the best discharge characteristics for digitals, they don't retain power as well as other types of batteries when stored. Alkaline batteries can be stored for a year or more, without significant loss of power. NiCads retain their charge for only a few months. NiMH batteries don't last anywhere near as long, so it's important to recharge them before using the camera, even if it has only been stored for a few weeks.

As with most electronic equipment, it's a good idea to remove the batteries when the camera is stored for any extended period of time. It's also a good idea to take out the removable media and transfer the images to a computer when storing the camera. The shots on the removable media won't be lost, but the media itself might get misplaced or damaged. Storing it separately, along with the camera, will protect it.

It's a slightly different procedure with cameras that don't have removable media. While some such cameras do have back-up batteries, most do not. That means the images stored in the internal memory are lost as soon as the batteries are pulled out. No matter what type of digital camera is being used, it's always a good idea to transfer images to the computer as soon after they are taken as possible. That protects them from accidental loss. For cameras with no removable media, even those that have back-up batteries, it's imperative to transfer images as soon as possible. It's not uncommon for both the main and back-up batteries to go out. When that happens, the shots will be lost.

Some higher-end consumer and business-oriented digital cameras utilize proprietary rechargeable batteries like the ones used for video cameras. They have a lot more staying power, and they have a much longer shelf life. Canon, for example, has a series of still digital cameras that can use both 6-volt lithium batteries and proprietary rechargeable batteries. That's pretty much the best of both worlds.

There are ways to maximize digital camera power when shooting. For one thing, keep the LCD off when actually taking the pictures. Using it to frame shots is handy, but the LCD requires more power than any other feature of the camera. Whenever possible, use the viewfinder to frame the shots. Along the same lines, don't spend too much time reviewing shots until the camera is attached to an AC adapter, or at least until it's possible to recharge the batteries.

> **FACTS TO NOTE:**
> To extend battery life when shooting with your digital camera:
> **1.** Frame shots with the viewfinder instead of the LCD.
> **2.** As much as possible, avoid reviewing shots on the LCD.

● Image Storage Options

The purpose of any camera is to capture latent images. The primary differences between conventional and digital cameras is how the shots are stored. With conventional cameras, images are captured and stored on film. With digital cameras they are captured on CCDs and stored in memory.

The first digital cameras only had non-removable memory, meaning that once the built-in memory was full, you either had to stop shooting and transfer the images to a computer or erase some of the shots before shooting again. That was a real pain. Even if you had a laptop computer, it was a pain to have to carry it along, just to download images to it when the digital camera memory was full. The other option—to stop shooting—was even less appealing. What good is a digital camera if it only takes ten or twelve pictures and then you have to stop shooting?

Removable media changed that. With removable media, it's possible to continue shooting

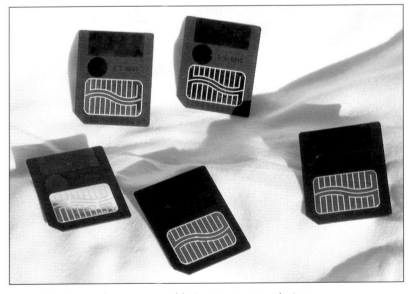

SmartMedia cards are removable image-storage devices.

simply by switching the media out once it's full. There are now various types of removable media, but the two most common ones for consumer digital cameras are

SmartMedia and CompactFlash. The manufacturers of these media are battling it out verbally, detailing the advantages of their type of media, while highlighting the shortcomings of the competing media. As with most things, the reality is that there are advantages and disadvantages to both.

SmartMedia is much thinner than CompactFlash, somewhat less expensive and probably the easiest to transfer to the computer. CompactFlash has higher maximum capacities and, because of its design, can be used in a much wider variety of electronic devices beyond digital cameras.

CompactFlash cards, which have sophisticated electronic circuitry built into them, also have options available to them not available with the competition. For one thing, as mentioned, they have higher capacities. There are two types of CompactFlash cards, the original type I and the newer type II. Type I cards already go up to 128 MB in capacity, while type II cards go up to 256 MB, and capacities are still increasing.

There are advantages to CompactFlash type II cards beyond their higher capacities. There are other types of devices being developed in the CompactFlash format. For example, IBM has released a miniature MicroDrive, a Winchester-type CompactFlash II hard disk drive ranging in capacity from 140MB to 1G. It writes and reads data just like any other hard drive does, except it's much smaller and fits into any digital camera that's CompactFlash II compatible. Another device being developed for CompactFlash II slots is a modem. On cameras with dual CompactFlash slots that support direct image transfer, using a modem in the second card slot makes it possible to store the captured images on one card and transmit them directly over phone lines or cellular service through the other.

Sony is utilizing two other forms of image storage for its digital cameras. Its Digital Mavica line uses standard high-density floppy disks to store images. When it was first introduced, the Digital Mavica quickly became the number one selling digital consumer model on the market. But its low storage capacity (1.44 MB per high density floppy), which in turn meant lower resolution shots, limited its applicability. Another Sony media that's getting a lot of attention, but hasn't gained widespread acceptance yet, is the Memory Stick. The consensus is that it will become increasingly important in the years ahead, but that's also what they said about Sony's Beta video tape format, and you know what happened to Beta.

FACTS TO NOTE:
Some common removable media formats for digital cameras include:
1. SmartMedia cards
2. CompactFlash cards
3. Floppy disks
4. Memory Sticks
5. PCMCIA cards

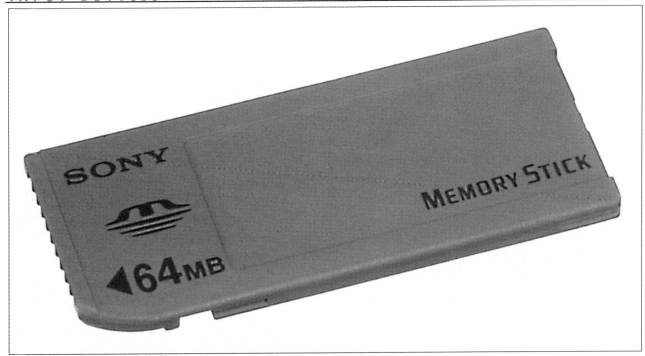

A storage option frequently used in professional and higher-end digital cameras is the PCMCIA (or PC) card. These cards are about the size of a business card, and only a little bit thicker. They're used extensively with laptops and other higher-end electronic devices.

Most cameras ship with either a 4MB SmartMedia or 8MB CompactFlash card. The number of images that those cards can hold can be misleading. Some companies say that their media cards can hold 36, 48 even 96 images per card at what they refer to as a "standard" resolution. Unfortunately, standard resolution is junk, for the most part. These images might be acceptable for the World Wide Web or other Internet applications, but frequently even there their capabilities are marginal. They would certainly not be applicable for blow-ups or publication.

Except for Web applications, it's generally best to shoot at the maximum resolution possible. As a rule, it's best to shoot at the resolution that an image is going to be used at. If usage requirements are known, or if they might be required for multiple uses, it's best to shoot at a higher resolution and scale the image down as needed. If you shoot at a lower resolution and then have to increase the resolution later, the image quality will suffer.

Sony's Memory Stick hasn't gained widespread acceptance yet, but is an example of another removable media format for digital cameras.

FACTS TO NOTE:
PCMCIA is an acronym for Personal Computer Memory Card International Association.

● Transferring Images to a Computer

All digital cameras have some way of transferring the captured images to a computer. For cameras with no removable media, that's always done by cable, usually via a

serial connection. Cable image downloading can be slow—very slow. Depending upon the camera model, the resolution of the image, the compression of the file, and the computer that the images are being transferred to, it can take anywhere from one to four minutes per shot. That can be a long time when you're transferring twenty, thirty, even forty images. Camera models that increase resolution through software as images are transferred to the computer have to transfer their images by cable; otherwise, such automated resolution enhancement doesn't work.

There are various options available to handle image downloads with cameras that have removable media.

Cable Downloads. As with non-removable media cameras, the first download method is by cable. Unlike cameras without removable media that transfer their images through a conventional serial connection, digital cameras with removable media increasingly utilize the new universal serial bus (USB) connectivity. Set-up for USB is easier than with traditional serial connections, and transfer times are faster. Higher-end digital cameras support "FireWire" connectivity, which not only provides much faster image transfer, but also the ability to control a digital camera directly from the computer. There are also some cameras that utilized SCSI (small computer system interface) technology for image transfer, but the number of cameras with SCSI connectivity is decreasing with the heightened popularity of USB and FireWire connectivity.

Card Readers. Another transfer option is the card reader. There are now card readers available that can be used to input image data from SmartMedia, CompactFlash and PCMCIA cards. They're attached to computers much like external floppy drives, and can read and write data to those memory cards. They're fast, effective and reliable. For laptops and other computers that already have a PCMCIA drive installed, there are also SmartMedia- and CompactFlash-to-PCMCIA adapters.

Printers. Still another way of getting images into a computer from SmartMedia or CompactFlash cards is through a digital printer that supports such cards. Those

For laptops and other computers with PCMCIA drives, adapters are available to use SmartMedia and CompactFlash cards.

(Left) Printers are also available that generate prints directly from removable media, without a computer. (Right) Flashpath SmartMedia adapter.

printers are designed to generate prints directly from memory cards, without having to upload the images to a computer. That's a great capability, particularly for photographers who don't want to mess with computers. Some of those printers also make it possible to transfer the images taken from the media cards to an attached computer.

Floppy Disk Adapter. One option available for SmartMedia cards, but not for CompactFlash, is a floppy disk adapter. For example, with the FlashPath adapter (which is a specific brand of adapter), once the drivers have been installed on the computer, it's a simple matter of sticking the SmartMedia card into the floppy-like disk and putting that disk into the drive. The computer sees the FlashPath disk as it would any other floppy disk, except there are anywhere from 4 to 32MB of data on each card.

Other Options. As the operating systems within digital cameras become more sophisticated, it will become possible to create an entire presentation within the camera, store it on one CompactFlash and back it up on another. To a certain degree, that's already possible with some cameras. Eastman Kodak's line of consumer digitals have an operating environment called Digita O/S that makes it possible to create slide shows and add special effects. Hitachi's M2 MPEG digital camera, which can take still digital photos, audio or full-motion MPEG video goes one step further. With it, you can create very sophisticated presentations that integrate still, audio and video elements. And, with the newest models, since it's possible to transfer data from a computer to the camera, presentations can actually be created on the computer and downloaded to the camera. That way you only have to carry the camera along to give a pres-

"... you can create very sophisticated presentations..."

entation. It's a simple matter of connecting cables to a TV or VCR video and audio-in plugs, and running the entire presentation off of the Hitachi. The Hitachi stores its d ata on high capacity PCMCIA hard drives, so both camera and storage cards can get expensive. Almost all higher-end digitals, such as the 35mm format models, utilize PCMCIA cards for storage. Most of those also support the IBM CompactFlash II MicroDrive, when used with a PCMCIA adapter.

Hitachi MPEG camera.

● Expanding Digital Image Capture Options

One of the advantages of digital over conventional photography is that it can be incorporated into other types of technology. Digital cameras are also being designed into devices in which people wouldn't think to find a camera. For example, Sony's new PictureBook laptop has a digital camera built right in. Images are taken by the rotating lens in the cover and displayed on the screen. Those images can then be imported into any application installed on the laptop that supports graphics—from photo albums and image databases, to human resources files and photo ID systems, or photo editing and natural media manipulation programs. They can also be posted on a Web site or sent as e-mail attachments through the computer's modem.

Anything that can be done with a digitized photo can be done with the shot taken by the laptop camera. Insurance adjusters can, for instance, take images of accident damage, and instantly incorporate them into their reports. Real estate agents can create entire databases of available properties without ever having to transfer a single file or ever work on a desktop system. The only limitation is the resolution, which isn't quite as high as some of the stand-alone digital cameras. Lower resolutions mean lower image quality when photos are printed out.

The trend of designing digital cameras into other types of devices will continue. Digital camera technology will be pervasive. It's already to the point that inexpensive toys like computer games have built-in digital cameras. Eventually, a wide variety of equipment, such as palm-top computers, pocket organizers, even cellular telephones, may have miniature digital cameras in them. That will make it extremely easy, for instance, to take a picture and send it over a cellular phone's built-in modem—without ever hav-

ing to download the image to a computer. The cellular and PCS phones that provide access to certain text-based Web sites will then be replaced by phones that provide full Internet access. They will not only be able to display Web images and graphics, but will also be able to be used to change them instantly.

Conversely, there are also going to be different types of equipment designed into digital cameras. One electronic device that is already available as an option for some camera models (and will likely become standard equipment on higher-end cameras) is a global positioning system (GPS) module. Just as some cameras (both film and digital) let you time-stamp the images as they are taken, GPS modules make it possible to stamp the exact location where the picture was taken. Using satellite data, GPS units provide highly accurate latitude and longitude coordinates along with extremely precise time marking. For consumers, that capability is more of a novelty, but for professional and business applications, GPS is an excellent tool for validating where and when a shot was taken.

Kodak DC290 with GPS unit.

A number of digital cameras have infrared transfer capabilities. With this, images can be downloaded to a computer that also supports infrared file transfer by simply placing the two pieces of equipment next to each other and running the transfer programs.

Infrared transfer works well enough when the equipment is close together and there's nothing interfering with the transmission. It doesn't work very well, however, at any great distance. That's why Bluetooth technology was developed. Bluetooth is a new short-range radio technology that exceeds infrared communications capabilities. Devices that have Bluetooth transceivers installed don't have to be right next to each other to communicate. They can be quite a distance away, in some cases, even in other rooms or across the street. A digital camera with a Bluetooth module built in can be used to transmit images to a larger computer down the hall, without having to tether the camera to a network. Images can be transmitted to cell phones and then sent around the world. That makes it possible to utilize high-resolution images and still easily transmit those shots wherever they need to go.

"... easily transmit those shots wherever they need to go."

3

SCANNERS

Digital cameras aren't the only way to get digital images. It's also possible to turn a slide, negative or print into digital data. That's done with a scanner. Scanners project light through transmissive material like film and slides, onto a sensor. That electronic data is then digitized. At that point, it's the same type of digital data that would come from a digital camera. Like with the other types of computer equipment, the prices of scanners have dropped. There are some scanners available that cost around $30, but if you're serious about photography, it's a good idea to spend a little extra and come up exactly with what you need. For most photographers who already have a large selection of shots in their photo libraries, a scanner is probably a better first investment than a digital camera. With it, it's possible to convert all those shots into digital images.

● Flatbed Scanners

There are a number of different types of scanners available. The most common ones are flatbeds, which are used primarily to scan prints. The resolution of scanners is climbing, but not quite as fast as that of digital cameras. At the same time, the quality of the scans that these units can generate is increasing. Flatbeds that can be used for digital imaging are very reasonably priced. While they are primarily designed to input prints, some can be used to digitize film and transparencies with special adapters, which are available as an option. And, because they do have a large flatbed, most scanners with transparency adapters can be used to scan in oversized transparencies that might not fit into dedicated transparency scanners.

"The resolution
of scanners
is climbing..."

A flatbed scanner.

For imaging, a flatbed scanner should have an optical scanning resolution of at least 600dpi (dots per inch). The resolution for most photo flatbed scanners is 1200dpi or more. Higher-priced models go all the way up to 4800dpi. One thing to make sure of when selecting a scanner is that the resolution being advertised is the optical, not maximum, resolution. As with digital cameras, optical resolution is different than maximum resolution. With scanners, the maximum resolution is usually a multiple of the optical resolution that's been increased through software. Scanning at a maximum resolution increases the pixel numbers and file size, but doesn't necessarily increase the quality of the images. So, as with digital cameras, it's best to compare scanners on their optical resolutions. The list for flatbeds is growing quickly, with dozens of models that work well. Which specific unit to choose is a matter of personal preference and needs.

> **TERMS TO KNOW:**
> The **dots per inch (dpi)** of an image refers to the resolution of an image. This number tells how much information is contained in a linear inch of the image. Higher resolutions generally provide higher image quality.

● Transparency Scanners

If you only need to input negatives or transparencies occasionally, or if you're working with oversized material, a flatbed with transparency adapter works well enough. Flatbeds, however, aren't the best choice for serious imag-

ing that requires inputting transmissive materials. In that case, a dedicated film scanner (also called a transparency scanner) is required. Just a few years ago, even entry level units were prohibitively expensive for most consumers. Again, prices have gone way down. Most consumer-oriented film scanners input 35mm film. Most can scan images in at 2700dpi—and at prices almost anyone can afford.

A transparency scanner.

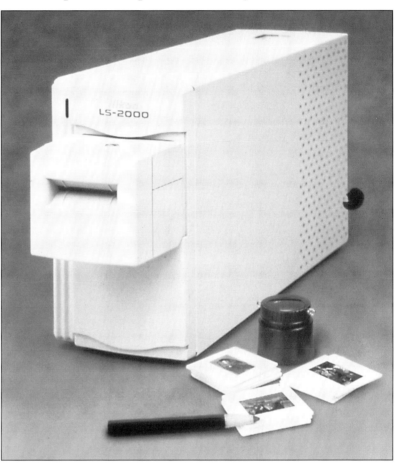

● Multi-Format Scanners

35mm and APS. There are also multi-format scanners that can take several different film sizes. For consumers, multi-format usually means 35mm and the Advanced Photo System (APS) film format. Such scanners are only slightly higher priced than exclusively-35mm models.

"... multi-format scanners can take several different film sizes."

Film and Prints. Another multi-format is a film scanner that can also take prints. Hewlett Packard, for example, has a film scanner that can also take snap-shot sized prints. That makes it a good choice for photographers who want the quality of a film scanner but occasionally need to digitize prints.

35mm and Medium Format. For commercial and professional applications, multi-format scanners usually take 35mm and medium format (2 $\frac{1}{4}$" x 2 $\frac{1}{4}$"). Because

they are targeted at professionals, multi-format scanners that can scan medium format film or transparencies are considerably more expensive than other types of multi-format scanners.

● Drum Scanners

There's yet another type of scanner, called a drum scanner, that's used for high-end scanning in photo labs and service bureaus. The quality of the scans that drum scanners can deliver is excellent—but with price tags that can run into the six figures, ownership is out of the range of even most professional photographers, and this book.

A drum scanner.

4

COMPUTERS

Computer systems are getting less and less expensive all the time. It's possible to buy an entry-level system for imaging and graphics for well under $1,000. Even higher performance systems targeted at consumers, which are capable of working with and storing relatively high-resolution images but don't have all the bells and whistles of professional systems, cost only a bit more.

Professional imaging systems represent a more significant investment, but are still within the range of many consumers. There's a lot of talk about graphic systems, Internet systems, business systems and a whole host of other system categories. That can be a little confusing. While virtually all computers can be used for graphics and imaging, their configuration determines the file sizes that can be worked with. The more robust the configuration, the faster the system and the larger the file sizes that can be handled.

● PC vs. Macintosh

Personal computers used for imaging are broken down into two broad-based categories: PCs (the computers that used to be called "IBM-compatibles" and run Windows 95, 98, 2000, and NT), and Apple Macintosh (which use the Mac/OS operating system). For a long time, the Mac dominated digital imaging. Some 70 to 80 percent of all imaging was done on them. A few years ago, Apple was having problems. During that time, it lost a segment of the high-end market to Windows NT systems. Initially, when consumer digital imaging first reached the market, because Macs were considerably more expensive than comparable

"Computer systems are getting less and less expensive all the time."

A professional imaging system.

PC systems, equipment manufacturers and software developers providing consumer digital imaging products totally ignored the Mac. In more recent years, a number of companies have provided consumer imaging products for that platform. For some users, the added price tag is worth it.

It's generally easier to configure Macs than PCs, and they come with more equipment and connectivity options as standard features than do most PCs. For instance, SCSI connectivity has been standard on the Mac since the mid-1980s. It's still an option with PCs. With Macs, connecting devices to the SCSI port presents no problems. With PCs, particularly with models that are a couple of years old and are running an older version of Windows, adding anything, including SCSI devices, could present problems. For purposes here, because Macs do come pretty much preconfigured, we'll concentrate on PC configurations.

"It's generally easier to configure Macs than PCs..."

● PC Configurations

Processor Speed. There are various characteristics in a computer that facilitate imaging. The first is the processing speed of the microprocessor, or central processing unit (CPU), that the system is designed around. Lower-end systems are usually designed around Intel Celeron CPUs, running around 400MHz (which is called the "clock"

speed). Designed for on-line activities, these types of systems are acceptable for low-resolution imaging, such as preparing shots for the Web, but they don't have the horsepower for working with higher resolution images. At the consumer level, an entry-level Pentium III is the answer. Running at 500 to 600 MHz, these systems are extremely powerful, yet affordable. There are several other components for an effective digital imaging system, including the amount of memory installed, the capacity of the internal hard disk drive, the video card and the connectivity options.

Memory. Along with the clock speed of the CPU, the amount of memory installed, expressed in megabytes (MB), has a direct impact on image-processing speed. That's because the more memory that's available, the more of the file that's being worked on can be stored in it. Working with images in memory is exponentially faster than having to read and write parts of the image file to the hard drive. Most Pentium III systems come with 64MB, which is sufficient for most consumer imaging. But, since

A selection of microprocessors.

the price of memory is quite low it's a good idea to add another 64MB.

Hard Drive Space. Hard drive space is important for image storage. The larger the hard drive is, the more images can be stored on it. That's important with high-resolution imaging.

Most on-line images are between 25KB (kilobytes) and 100KB in size. At 100KB, fourteen such images could be stored on one high density floppy. File sizes climb rapidly, though, when working with uncompressed, high resolution images. Shots taken with consumer digital cameras can be several megabytes in size. Shots taken with lower-resolution professional digital cameras and those scanned in can be 20MB to 30MB in size. On the high end, some professional image files can be 100MB or more each.

It may not seem like it, but with multiple copies of individual shots; variations such as horizontal and vertical orientation, and similars with only slight compositional differences, the number of image files can mount up very quickly. At a minimum, hard drives should be 5GB or 6GB in capacity—and 12GB to 14GB is better.

Video Board. The video board is another factor, but for most still imaging, not as much of of a factor as it used to be. Early PCs didn't have any color capabilities. When color was introduced, computers could display all of sixteen separate colors. That was well before digital imaging, even before serious computer graphics, so there wasn't a great need for color. The biggest color requirements at the time were for such things as differentiating between regular and underlined text in programs like WordStar™, or for pie charts and bar graphs in financial spreadsheet programs like Lotus™ 1-2-3.

Over the years, the number of colors computers could represent has gone up steadily. The sixteen colors, which were common with CGA (computer graphics adapter) video systems, jumped to 256. This became the norm for EGA (enhanced graphic adapter) video systems. Early standard VGA (video graphic adapter) systems also displayed 256 colors, called 8-bit color. Higher color displays became available, but they were very expensive. Two VGA color options became available about the same time: "high color" and the more common "true color." "High color" VGA initially could represent 32,000 different colors (15-bit) and later 64,000 (16-bit) colors. True color, which is 24-bit color, was a big jump in capabilities. It can represent 16.7 million colors. When they first reached the market,

FACTS TO NOTE:

1. For serious imaging, drives with 20GB-plus capacities aren't too large. The amount of memory and size of the hard drive can both be easily upgraded when the system is ordered.

2. Pentium III CPUs are also used for very high-end imaging, but their clock speeds are about fifty percent faster.

3. Cutting-edge systems are considerably more expensive than mid-range ones. It can cost almost twice as much for an imaging system that has twenty or thirty percent more processing power. So, if system performance has to be weighed with budget considerations, it makes more sense to go with a mid-range system.

Video add-on boards.

> "... most personal computers ship with Super VGA color capabilities."

true color video graphic adapters could cost as much as $600 to $800. In comparison, high color cards cost $200 to $300.

Increasingly, most personal computers ship with Super VGA color capabilities. The number of colors S-VGA can display remains the same, 16.7 million, but the pixel resolution it supports jumps from the standard 640x480 to as high as 1024x780 pixels. The higher the display resolution, the tighter the images look on screen. The greater the color depth of a captured image, the larger the image file will be.

Some video boards also support multiple monitors. That makes it possible to keep the document or image open on a larger monitor while keeping all the software tools ready for use on a secondary monitor.

With single monitors, it's a good idea to have at least 8MB of video memory, but 16 is better for serious imaging work. Along the same lines, it's important to select a monitor that can support true color at higher resolutions. As far as size is concerned, for on-line and Internet imaging, which doesn't require high-resolution image display, a 15" monitor is sufficient. For more involved imaging, a 17" model is a good choice, while for serious digital imaging, a 19" or 21" monitor is best.

COMPUTERS AND IMAGING SOFTWARE

● Connectivity

An important aspect that is often overlooked is connectivity. As mentioned in the image transfer section, connectivity is important to get the images that a digital camera or scanner captures into the computer. Connectivity standards are changing. The two types of connectivity that more computer users are familiar with are parallel (also called the printer port), and serial (also called the communications port). But USB and FireWire are both increasingly important. SCSI is still around, but it's not as dominant a high speed connectivity option as it once was.

Any accessories purchased for the computer have to match the connectivity capabilities of the system that they're going to be used with, otherwise upgrades to the system are required. For someone just getting into imaging, it's best not to mess with upgrading systems right away. And having upgrades handled by a computer store's service department can get expensive. Frequently, the service center charges as much, or more, to install an add-on board or other component as the equipment itself costs.

● Buying a Computer

Buying a computer can take a little time. It's better to take the time to figure out just the right model than to hurry and find out that the purchase was a mistake.

On top of that, careful shopping can result in substantial savings. There are a lot of good buys on the market when it comes to entry-level and mid-range systems. Some people prefer to go for the rock-bottom price. If that works for them, that's okay. I prefer to buy the best piece of equipment I can afford at the time, so I tend to go with major brands when I upgrade.

The number of reputable companies selling very affordable computers is climbing all the time. Dell, Gateway and a host of other companies are targeting consumers with their marketing efforts and low-cost systems. Companies like Compaq and Hewlett-Packard are somewhat higher up the ladder, with systems configured for imaging costing slightly more.

FACTS TO NOTE:
Understandably, computer salesmen try to sell as many system accessories as possible. One accessory that they present as a must-have for imaging and graphics is a graphics tablet, instead of a mouse. Graphics tablets are great, but when starting out, a mouse works fine, and it usually comes free with the system. Once you have an idea of how you're going to use your new computer, you can always add the graphic tablet that best suits the way you work. For some reason, some people like certain graphic tablets, while others may not like those type at all. I probably have a half a dozen or so graphic tablets, but I still use a mouse for most digital imaging.

5
DIGITAL IMAGING SOFTWARE

While camera gear and computer hardware are important in digital imaging, the main component is software. Software determines what can be done once a picture has been turned into a digital image. There are all sorts of programs on the market. The list of titles is virtually endless.

● Raster vs. Vector Software

Software used for working with illustrations and images, generally referred to as graphic software, is broken down into two broad-based categories: vector-based programs and raster-based programs. Vector programs, like Adobe® Illustrator® and Macromedia® Freehand®, primarily work with illustrations, ranging from such simple things as line art, texts, and graphic elements, to complex integrated objects like logos and other design projects. Those programs work with graphic elements on the screen through mathematical equations. A line, for example, would be defined by the positions of its two terminals along with its characteristics such as its width and style. Raster programs, like Adobe® Photoshop® and Ulead® PhotoImpact®, are used for photographic digital imaging. They can manipulate each individual pixel in a digital photo.

At one point, the gap between vector and raster programs was almost unbridgeable. There existed what were called "tracing programs" that, in theory, could turn raster files into vector files. There were also some raster image processing (RIP) programs that were able to convert the mathematical equations of vector files into the pixel by pixel raster files. But, in both cases, the process frequently took a long time, and the results were often less than satis-

> "The list of titles is virtually endless."

factory. Software programs designed to work with images and graphics are still segmented into vector and raster, but it's now a lot easier to go between the two types of programs. Most vector programs make it easy to incorporate a photographic image into an illustration. Conversely, most higher-end raster programs make it possible to add graphic elements, such as lines, logos and text. There are now some programs with both types of modules, making it relatively easy to bounce back and forth from one type of file manipulation to the other.

● Color Management

More than 95 percent of all photography is color photography, so virtually all digital imaging software works with 24-bit true color images. Working with color on the computer is a complicated process. In each step of that process, from scanning or capturing a digital image to

> **TERMS TO KNOW:**
> **Vector graphics** are digital images (usually line art or other illustrations) that are represented through mathematical equations.
>
> **Raster graphics** are digital images (such as photographic art) that are represented as individual pixels.

Color management software.

image transfer and modification in the computer, to output on a printer, film recorder, or CD, color is represented differently. The scanner, the computer monitor, the printer and any other device being used in the process all have their own way of working with color, which is called a "color space."

The color space of the devices have to be controlled effectively to come up with good results. At each step of the process, there is the potential for problems. In order to make sure that the color in the captured or scanned image is the same in the computer and on the monitor, and, in order for the color that the output device represents to match the color being worked on in the computer, some form of color management is required. Some of the commercial software programs have color management modules, which suffice for casual digital imaging. For serious digital photography, however, it's a good idea to invest in specialized color management software, which makes it possible to fine-tune the color production process.

● Adobe® Photoshop®

Adobe® Photoshop® dominates digital imaging software. It's been around for more than ten years for Macintosh systems, and just a few years less for PCs. While there have been some very good programs over the years that have challenged Photoshop (including Aldus Photostyler®, Live Picture®, X-Res®, among others) none have even come close to gaining the type of acceptance Photoshop® has achieved. It's been estimated that seventy to eighty percent of all professional level imaging is done in

FACTS TO NOTE:
Consumer digital imaging software is much more fragmented than professional imaging software. There are literally dozens of programs available. For photographers who want to work in a full-feature image editing package but don't want to spend the money on Adobe® Photoshop® there are programs like Ulead®'s PhotoImpact® and JASC®'s PaintShop-Pro®. They're inexpensive, but still offer considerable power.

Adobe® Photoshop® screen shot.

Photoshop®. There's a reason—it has some amazing capabilities that make it well worth its relatively steep price.

Manipulation and Enhancement Capabilities. This isn't really meant as a software tutorial, but it's a good idea to understand what image editing programs are capable of in order to get the most out of the equipment.

Imaging programs like Photoshop® can be used to handle basic image optimization. That might include adjusting brightness and contrast, changing the hue or cast of a shot, sharpening the image, and removing dust spots and imperfections. They can also be used to change sizes, resolutions or orientation. And they can be used to manipulate images, which might include "cloning" (copying a part of one image into another shot, or into another part of the same image), cutting and pasting various parts of one or more images, and adding other elements to a composition.

> "They can also be used to change sizes, resolutions or orientation."

Cloning functions on digital imaging software can help you replicate elements in a photo (or copy and paste items to a new photo).

Higher-end digital imaging programs utilize "layers" to work with images. Each individual color channel is on a separate layer, and users can add additional layers for image, graphic and text elements. There are numerous advantages to working with images in layers. One of the most important ones is that these images remain editable. In other words, as long as they stay in the proprietary file format of the imaging program, they can be changed as many times as needed. Any changes that are made can easily be undone if they aren't just right. However, once an image is saved in a generic file format, changes can't be undone.

Output Capabilities. Besides the extensive image manipulation and enhancement capabilities, Photoshop® also has some interesting output capabilities. The latest version has an enhanced print module incorporated into it that makes it possible to print complete sets of pictures, like the packages of school pictures that kids get. Package prints might include an 8" x 10", a couple of 5" x 7"s, several 3" x 5"s and some wallet-sized prints, which can be printed with a few mouse clicks. Another addition to Photoshop® is the ability to optimize digital images for the Internet and the World Wide Web.

● Plug-ins

Image editing packages extend their functionality with what are called plug-in filters. These software modules add capabilities to primary image editing programs. There are hundreds of plug-ins available. They can be used for such things as turning a photograph into a charcoal etching or other work of art, as well as embossing, blurring, and other special effects. Most imaging programs ship with a set of fundamental plug-ins. There are also third party plug-ins that add even more functionality to the core program. They can be used to do things like generating very sophisticated works of art, adding borders or frames and giving images a stained glass window look. Initially, there were proprietary plug-in filters for different imaging programs. Increasingly, most image editing programs support Adobe-compatible plug-ins, so it's possible to use the same plug-ins with whatever image editing package might be installed.

● Photo Compositing

The integration of various images, graphic elements and text into one cohesive design is referred to as photo compositing. In the early days of digital imaging, all image manipulation software was expensive, but photo compositing programs were particularly high priced (roughly double the price of professional image editing programs). However, they revolutionized computerized creative design. Software like Ron Scott QFX®, one of the first image editing programs that had an excellent imaging module and did a very good job of working with vector elements, set the standard for photo compositing.

Today, there are inexpensive integrated programs that can do many of the things that earlier expensive programs could do, at a fraction of the price. Two popular photo compositing programs are Microsoft PictureIt® and Adobe®

"... software plug-ins add capabilities to primary image editing programs."

Using a compositing program can make it easy to turn a favorite digital photo into a greeting card, calendar or other professional-looking product.

PhotoDeluxe®. They are both excellent at handling a variety of projects that incorporate images, text and graphics. Some photo compositing programs include specific package print modules that are matched to specific substrates. Those programs will automatically format output to match, for example, a specific Avery® paper product. That makes them ideal for creating professional looking projects, greeting cards and promotional materials.

There are a number of advantages to utilizing compositing programs. With them, any image in a composition is re-sized to match output requirements. Because of the sophisticated way that compositing programs resize their images, image output is frequently better when the shot has been changed dynamically in a compositing program than in an image editing program. At the same time, any text, graphics or other vector elements in a composition are a lot sharper, regardless of the output size. As an example, creating an 4" x 5" composition with image, graphic and text elements in an image editing program works well enough when it's printed out at 100% (actual size). But, if that image has to be enlarged up to 8" x 10" (200%), all the graphic elements are increased in size pixel by pixel. New pixels are created to achieve the larger dimension while retaining the number of dots per inch. This will increase the appearance of imperfections. That's why images sometimes look pixelated, with all the lines that are supposed to be sharp having jagged edges (or jaggies, as they are called).

"This will increase the appearance of imperfections."

The same composition, in the same 4" x 5" size, with its resolution increased in a compositing program has far fewer imperfections because the program takes that original data and actually recreates the composition in the larger size. The down side of some photo compositing programs is that they don't provide all the image editing options higher-end image manipulation programs do. Many photographers utilize both an image editing and a photo compositing program to get the best of both worlds.

If basic image optimization is all that's desired, most of the programs that come with digital cameras and scanners will suffice, without the need to purchase additional software. Many cameras ship with limited editions of popular image editing programs. There are also specialty imaging programs available. For example, a natural media program like Painter® goes beyond the capabilities of image editing and compositing programs in turning photographs into works of art. Once a shot has been transformed in Painter, it can look as natural as any hand-crafted work of art.

"Many cameras ship with limited editions of popular image editing programs."

Compression and File Formats

File Formats. Almost all image editing, photo compositing and natural media programs work in numerous different file formats. Higher-end programs have their own proprietary formats to simplify image manipulation. Once all the modifications have been made, images and compositions can be saved in a widely used file format.

When taking all the variations and subsequent generations into account, there are close to one hundred different types of image file formats. The most common are TIFF (for both PCs and Macs) and PICT (on the Mac). There are also different formats that compress image file sizes to make it possible to store more images on a disk and to increase image transfer speeds for Web pages and e-mail.

Compression. There are two types of compression file formats: lossless and lossy. With lossless compression, an image's storage size can be reduced without any image data loss. That means when it's uncompressed, it's exactly the same as it was originally, pixel by pixel. That's the best way to achieve image quality, but not maximum compression. Lossy compressing can crunch a file size down more, but there's a price to pay. When the image is uncompressed, it's close to the original, but not exactly like it. It's good for getting a file size down to the minimum.

● Tutorials

Once you're pretty sure that digital imaging is for you, it's a good idea to go through the various programs' tutorials. They are one of the best ways to learn the features and capabilities of the software being used. There are also a wide selection of books covering various software packages on the market, ranging all the way from simple introductions to books detailing complex imaging capabilities and unusual techniques. Almost all programs also provide on-line help, which is usually stored on the CD the software is shipped on.

Whether you shoot indoors or out, mastering your image editing software will help you make the most of every image.

6

DIGITAL PRINTERS

● Photographs vs. Photo-Realistic Prints

Digital printers take the data that a digital camera, scanner or computer generates and create photos from it. Conventional photographs printed in a darkroom are generally referred to as "photographs," while digital prints are generally termed "photo-realistic prints." The difference between the two is diminishing as more and more machines that can take digital data and print it to true photographic materials reach the market. Still, it's useful to quickly distinguish between the two types.

To the average person, photographs and photo-realistic prints don't look all that much different, but, on closer examination, they are quite different. Photographs are continuous tone prints; that means, for one thing, they can contain an infinite variation of colors, hues and tones. In photographs, the colors are also solid. In other words, when looking through a loupe (a small magnifying glass used to look at photos and transparencies) there's no white space or other type of dot pattern visible.

Most digital printers can generate 24-bit color, meaning, in theory, that they can reproduce 16.7 million colors. That may seem like a lot, but considering that the eye can distinguish billions of color variations, it isn't all that many. And, because of the way that digital printers represent color, most can actually only print a fraction of those sixteen million colors. For some commercial presses, for example, the gamut (the set of colors that any output device can produce) is represented by as few as 800,000 color variations. That's still a lot, but the difference in color between the two types of prints is noticeable. Additionally,

"... the difference in color between the two types of prints is noticeable."

rather than representing color continuously (as it is in the real world, and, to a more limited degree, in true photographs) digital printers lay color onto a print dot by dot, which is closer to how newspapers and magazines reproduce images than how they are printed photographically. You're talking about thousands of dots being laid onto the paper per second, but they are still individual dots. If those dots are too far apart (the image doesn't have a high enough resolution or the printer isn't capable of generating images with tight dot patterns) the quality of the print suffers.

There are various types of digital printers on the market, but the two most popular types are dye-sublimation and inkjet. Within each technology, the more dots there are, the higher the quality of the photo print. While a resolution comparison between two printer models utilizing similar technologies is valid, comparing resolutions of competing technologies isn't. For example, comparing resolutions for dye-sublimation and inkjet doesn't work well. Depending upon which manufacturer's dye-sublimation and inkjet printers are being tested, a 300dpi dye-sublimation print can look sharper than a 1440dpi inkjet print under a loupe.

⊙ Dye-Sublimation Printers

For a long time, dye sublimation was the preferred imaging technology for generating digital prints. It provided the closest thing to true photographic prints. But dye-sublimation printers were expensive—as much as $20,000. Many professional photographers were willing to pay such high prices for printers like the original Kodak XL-series printers. The ability to generate high quality, high resolution digital prints instantly was a major advance in commercial photography.

In the last few years, prices for consumer-oriented dye-sublimation printers have dropped. Some dye-sublimation printers that can generate 8" x 10" and 8 $1/2$" x 11" prints are available for a couple thousand dollars. One of the first companies to break the dye-sublimation price barrier was Fargo. For around $1,000, it was possible to purchase a printer matching the output capabilities of printers that cost eight or ten times as much. There are also lower-priced consumer-oriented dye-sublimation printers. They cost only a few hundred dollars, but are limited to snap-shot print size. Olympus, Fuji and Sony, among other companies, all market such printers. Some can print not only from the computer, but also directly from removable media.

Dye-sublimation printer.

● Inkjet Printers

The other major printer category is inkjet. Inkjets have been around for some time, primarily for professional applications. Photo labs and specialty service bureaus have been using them to generate poster-sized commercial output and display materials since the early 1990s. Those machines were expensive. Consumer inkjets have been around for a few years, but initially suffered from poor image quality. They were better for adding a "spot color" to a document than photo-realistic printing. Additionally, they had bad problems with light- and water-fastness.

Archival Quality. Over the last couple of years, things have changed somewhat. Inkjet printers can now produce excellent photo-realistic prints that rival what can be done by dye-sublimation printers. Where they still fall short is shelf life. Light fastness has improved, though. Previously, an inkjet print might have started fading in less than a year.

Inkjet printer.

Now it takes several years before fading even starts, and much longer before it becomes a real problem. Unfortunately, improvements haven't been that dramatic when it comes to water fastness. The touch of a moist hand or a drop of water can smear the print. If moisture gets onto true photographs, the surface is marred, but the underlying image is still there. With an inkjet print, the image is obliterated when it gets wet.

Some companies that produce inks, papers and other substrates claim that output printed with their material lasts as long as traditional photo prints. Epson produces a printer, ink and substrate combination it says will last 200 years—much longer than photographic materials. Unfortunately, the simulation tests used to test papers and inks haven't been proven by real world experience, so it's not a bad idea to be a little suspicious about those claims. Inkjet consumables haven't been around long enough yet to complete actual image deterioration tests over years and decades. Some are in progress, however.

It's always a good idea to print an extra set or two of important images, just in case one of the prints does get damaged. Inkjets have become the dominant digital print-

"... be a little suspicious about those claims."

ers for photo-realistic printing. Even many professionals who had the higher-end dye-sublimation printers installed have moved over to inkjet. Dye-sublimation printers are now primarily used for professional production work.

Resolution. As with almost all types of computer equipment, prices for photo-realistic inkjet printers have dropped dramatically. High quality inkjets, which can be used for professional printing and oversized output, can be purchased at prices even casual photographers can afford. Probably the most important thing to keep in mind when looking at inkjet printers is resolution. Newer inkjets have resolutions of 1200dpi, 1440dpi and higher. Most can also print at lower resolutions to increase output speed when generating documents.

Print Head. Most manufacturers have their own print head technology, which they claim is better than the rest. There are differences from manufacturer to manufacturer. Epson, for example, uses what the company calls micro-piezo technology, a form of printing that generates very small dots on the paper, making images look sharper.

Inks. A major consideration with inkjets is the number of ink wells. Conventional commercial printing utilizes four ink colors (CMYK): cyan (C); yellow (Y); magenta (M), and black (K). Previously, inkjets also utilized CYMK. Commercial printers found out that adding an additional color set (with the hue for each CYM color being different) resulted in higher-quality print output. More and more, inkjets also have multiple ink sets. The added inks provide for smoother gradients and more realistic skin tones, among other advantages. Other considerations for selecting an inkjet include the capacity of the paper input tray, the ability to take things like envelopes and odd cut sizes, and the cost of replacement inks. A complete set of inks can cost half as much again as the printer did originally, so making the right choice can have a direct impact on operational costs. Epson®, Canon®, Hewlett-Packard® and various other companies make excellent photo-realistic inkjet printers.

Print Size. Most consumer inkjets take letter size paper (8.5" x 11") or slightly larger. Some can take 11" x 17", and a few of Epson's new models can go even slightly larger than that. Such printers make it possible to print out two full pages, as they would be printed out in a magazine or brochure. By printing one oversized page, front and back, it's possible to create a four page brochure or newsletter—it's just a matter of folding it down the middle. These printers could also be used to print large blow-ups of individual

FACTS TO NOTE:
Output can also be generated on film recorders, which take the digital data in the computer and write to film or transparencies. That makes it possible to make negatives and slides from the digital data. Both of those types of technologies are expensive, generally beyond the price range of even most professional photographers. It's nice to know, though, that such services are available commercially when they're required.

shots or photo composites. Oversized printing is a very handy capability. For all their capabilities, these units don't really cost that much more than letter-size only printers—usually about fifty to sixty percent above the same standard-sized printer.

There are also wide and super-wide inkjet printers available, anywhere from 24" to over 100" wide. They're used to create display materials for billboards, trade shows, point of purchase displays and marketing collateral material.

● Inks and Papers

One of the things that has made the printing of photo-realistic images on inkjets possible, both on the professional level and the consumer side, is the development of better consumables—the inks and papers that are used to generate the image. When digital printers first came onto the market, the paper stock being used felt flimsy; it had no weight and no body to it. During the last few years, there have been tremendous advances in consumables. The color characteristics of inks are much better now than they were before. And both the quality and selection of substrates (as

FACTS TO NOTE:

Though not a significant percentage of overall digital imaging, there is some black and white work being done on the computer, and digital printers are very good at reproducing rich, saturated black and white photos. To be precise, photographic black and white and computer black and white are not the same. Photographic black and white images are continuous tone photos, which are called grayscale images on a computer. Like the early color video systems, which could represent 256 colors, grayscale images are also 8-bit. They can represent 256 shades of gray. Two-bit computer images are what would generally be considered line art. Everything is either black or white, with no shades of gray in between, like type or a pen-and-ink drawing on a sheet of paper. High-quality grayscale images can be output on most color photo-realistic printers. In fact, the effect that sometimes comes up when generating a grayscale print on a color photo-realistic printer while the settings are still on color output can be very interesting. Some models add a nice tonal quality to the image.

"That gives them a very professional look."

paper stock is called) have increased significantly. Dye-sublimation and inkjet papers now look and feel like true photographic material. The stock is firm, colors are crisp, blacks are saturated, and image definition is excellent.

For consumers, most inkjet output is done on higher-quality plain paper. It can be used to create documents and graphic designs. It's inexpensive and looks pretty good. For imaging, though, special photo paper is required, which can be glossy or matte finished. It's somewhat more expensive. Depending upon the manufacturer and the type stock it is, it could run $2 and more for an 8.5" x 11" page. That's still cheaper than color photographic material of the same size.

There have been a number of developments recently that have increased the types and sizes of substrate available. For one thing, project-oriented imaging programs have added package-print modules. That makes it possible to print multiples of the same image or design. Paper manufactures are offering complete selections of stock for things like business cards, brochures, invitations and the like. Some are pre-perforated, making it easy to, for example, tear the individual business cards down to size. Others are pre-scored so that invitations and other output that requires folding are folded precisely. That gives them a very professional look.

Also, different sizes of paper stock are becoming available, including such items as postcard stock (which comes preprinted with the postcard text side already on it) and panorama stock (which can be used to print panoramic

shots easily). And finally, the selection of substrates that are available is expanding. Besides plain paper and coated photo stock, it's possible to get such specialty substrates as canvas and metal foil.

● Compact Discs

Another option that's just recently become affordable enough for consumers is CD output. The new inexpensive CD writers make it possible to self-publish images on CDs.

Until just a few years ago, generating Photo CDs, as Kodak calls them, required sending the processed negatives and slides to a Kodak-licensed service bureau that would scan the images and create the Photo CD. The service was introduced in 1992, being targeted at professionals. Consumers, however, took to it faster than professionals, even though it was a little on the pricey side, costing anywhere from $1 to $3 per image. Since each Photo CD could hold roughly one hundred high-resolution images, that could get expensive.

More recently, Kodak, Intel and Adobe have developed another CD format, specifically aimed at consumers, called Picture CD. Picture CDs can be ordered when the film is taken in for processing. Instead of just having the photographer's shots on the Picture CD, it also comes with articles, pictorials, tutorials and other digital content, almost in the form of a photo magazine. Picture CDs are considerably less expensive than the Photo CDs, but offer lower resolutions, making them less useful for professional applications.

The dropping prices of CD writers has made it feasible for photographers who want to generate their own CDs to do just that. There are actually various types of CD formats, including CD-R (CD recordable), which can be written to once, making it a good choice for archiving images, and CD-RW (CD rewritable), which can be written to and over-written repeatedly.

The number of shots that can be stored on each CD varies greatly, depending upon such things as file format, resolution and compression. You can have as many as 4000 smaller shots, referred to as thumbnails, on a CD that serves as a photo catalog. Usually, for consumer imaging, 100 to 200 shots fit onto one CD. But remember, CDs created at home are not actually Photo CDs or Picture CDs. Consumer-oriented CD writers cannot write those proprietary formats.

"Picture CDs can be ordered when the film is taken in for processing."

○ Internet

"Another way of distributing images is online."

CDs are an excellent way to store and distribute images. Another way of distributing images is on-line. That could mean posting them onto a Web site, which (unless it's password protected) could be accessed by anyone in the world, or sending them as e-mail to anyone with an e-mail address. That's as effective a way of getting images to someone in another part of the world as it is getting them to someone on the other side of town.

Sending your digital images as e-mail or providing them for download on your web page makes it easy to get your pictures to the people who want them.

CONCLUSION

Changes in digital imaging are coming at break-neck speed. What's state-of-the-art technology one week, is old hat the next. The fastest computer system can be outdated by the time all the software is installed on it. Manufacturers are constantly introducing new equipment and, in the process, trying to convince consumers that what they are working with is hopelessly outdated.

This is not to make you worry. In fact, hopefully, this will reassure you, at least to a certain degree. You don't have to replace equipment constantly. That supposedly out-dated computer system will do what you purchased it for indefinitely, as long as there isn't a mechanical failure. Along the same lines, not everyone needs a powerhouse system. Older Pentiums work fine for most casual photographers interested in doing image optimization and preparing shots for Web pages and on-line activities. Those users who have a 450MHz or faster system installed will find it very effective for most of their imaging needs—even higher-resolution imaging. Systems with 750MHz and higher are more applicable for video production and animation, but unless super high-resolution imaging is involved, such speeds just aren't required.

Hopefully, after thinking about some of the advice presented here, you'll feel comfortable enough to get involved in digital imaging. The important thing to remember is, like photography in general, digital imaging is a trial and error process. The more practice, the better the results will be. And that's really one of the advantages of digital imaging. It's possible to shoot a lot, without having to worry about the price of film or processing.

"Changes in digital imaging are coming at break-neck speed."

GLOSSARY

aperture

The lens opening that allows light to enter the camera. Aperture is denoted by f-stop and controls depth of field in the photograph.

APS

(Advanced Photo System) A film (24mm) and camera format designed primarily for snapshots and other consumer uses.

archival quality

The ability of a photograph or photo-realistic print to resist deterioration over time (generally about 50 years).

auto-exposure

Camera function whereby the aperture and shutter speed are determined by the camera, rather than the photographer.

auto-focus

Camera function whereby focus is determined by the camera, rather than the photographer.

batteries

Portable power source used by all digital cameras and many traditional cameras. (*See* also NiCad and NiMH batteries.)

card reader

A hardware unit installed on a computer that allows removable media from digital cameras to be transferred directly to the computer.

CCD

(Charge Couple Devices) Much like film in a traditional camera, CCDs capture digital images in a digital camera. They are measured by resolution.

CD burner

A hardware device used to write digital files from a computer onto CDs.

CD-R

(Compact Disc—Recordable) A removable storage media that can be written to once by a CD burner.

CD-RW

(Compact Disc—Re-Writable) A removable storage media that can be written to multiple times by a CD burner.

CGA

(Computer Graphics Adapter) An early computer graphics system capable of displaying only sixteen colors.

cloning

A tool included with image-editing software that allows the user to copy and paste (or "clone") parts of an image and move them to another area (or another image).

CMYK

A color space designed for printing with four inks—cyan (C), magenta (M), yellow (Y) and black (K). This type of printing is used by most commercial printers and

many inkjet printers.

color management

Control of device color space in order to produce accurate color reproduction.

color space

Method by which individual pieces of software and hardware interpret and work with color.

CompactFlash

A popular format of removable media for digital cameras.

compositing

The combination of multiple images, text and/or illustrations into a single digital image or illustration.

compression

Reduction of the file size of an image to make it easier to store and/or transport (upload/download).

compression (lossless)

Reduction of the file size of a digital image without loss of image quality (data). This is an option with images stored in the TIFF format.

compression (lossy)

Reduction of the file size of a digital image with an accompanying loss of image quality (data). This occurs with images stored in the JPEG format.

consumables

Papers, inks and assorted other products used in printing that must be periodically replenished.

CPU

(Central Processing Unit) The microprocessor which is the "brain" of the computer.

digital imaging

The entire process of creating images using data in the form of numbers (digits), as opposed to creating images with chemicals and other physical products (as with traditional film imaging).

digital resolution

The maximum resolution that can be attained by a scanner or digital camera.

Uses equations to expand the number of pixels based on those actually "seen" by the device. (*See* optical resolution.)

dpi

(Dots Per Inch) The measure of the amount of information contained in a digital photograph. The higher the dpi, the more information (pixels) is contained and the more detailed the image will be.

drum scanner

A professional-level device used to create high-quality digital images from traditional media (such as negatives or prints).

dye-sublimation printer

A printer that uses heat to transfer color to paper. This type of printer can represent 16.7 million colors, creating very high-quality photo-realistic prints.

EGA

(Enhanced Graphics Adapter) An early computer graphics system capable of displaying only 256 colors.

8-bit color

The digital ability to display 256 colors. This is the color range of EGA systems.

f-stop

The measurement system used to express the size of a lens aperture setting.

15-bit color

The digital ability to display 32,000 colors. This is the maximum color capability of early standard VGA systems.

file format

A way of encoding images in a digital file for storage. Common file formats include JPEG (or JPG), TIFF and PICT.

FireWire

A common interface type that allows external hardware to be linked to a computer, and data to be moved to/from it. Fast data transfer rates and easy set-up often makes FireWire preferable to other interface types (such as SCSI and USB).

flatbed scanner

A device used primarily to convert prints into digital images. Some flatbed scanners

are also equipped with transparency adapters, which allow them to be used to scan transparent media.

floppy disk

A removable media format used by some computers and digital cameras to store digital files. Each floppy disk can hold 1.4-2MB of information.

focal length

Distance from the lens to focal plane when the lens is focused on infinity. Focal length determines magnification (longer focal lengths yield greater magnification, lower lengths yield less).

gamut

The set of colors that a particular output device can produce.

gigabyte (GB)

(1000 megabytes) Unit of measurement often used to describe the capacity of large digital storage devices, such as hard drives.

GPS

(Global Positioning System) A satellite-linked system which, when added to a camera, allows it to record the precise location at which a photograph was taken.

graphic tablet

A pressure-sensitive tablet and "pen" that are used to control the on-screen cursor (much like a mouse). Often used in digital imaging where very precise operations may be difficult to make with a mouse.

grayscale

The term digital imaging uses to describe images that would be called "black & white" in traditional photography.

hard drive

Computer's permanent (not portable) digital storage unit which may be internal or external (often connected to the computer via SCSI or FireWire ports).

hardware

The permanent, physical components of a computer system (such as the CPU, monitor, scanner, keyboard, etc.).

image optimization

Use of digital software to make images look their best without significantly altering the image content. Such changes include improving contrast, cropping, etc., as opposed to photo manipulation and/or compositing.

infrared transfer

The use of infrared light to transmit data from one piece of hardware to another. Requires the two pieces of equipment to be placed relatively close together.

inkjet printer

Photo-realistic color printer which creates images by spraying tiny individual droplets of ink onto paper.

ink wells

Ink storage devices within a printer. The number of ink wells may be four (for CMYK printing) or more (for even higher-quality print output).

input device

A device, such as a scanner or digital camera, used to create a file to be transferred to and used on a computer.

JPEG (or JPG)

(Joint Photographic Experts Group) A compressed file format used for up to 24-bit (16.7 million colors) images. The compression with the image format is considered "lossy," meaning that data is lost in the compression (resulting in reduced image quality, but smaller file sizes).

kilobyte (KB)

(1024 bytes) Unit of measurement commonly used to describe the size (memory required to store) of digital images.

latent image

Image that is recorded, but can't be seen until the film is processed.

layers

In digital imaging software, a way of working with an image so that different elements are on different levels. One level may be deleted or changed without affecting the others.

LCD

(Liquid Crystal Display) Type of display unit commonly found on digital cameras and used to compose and review images.

lens speed

Maximum amount of light a lens lets in. The faster the lens, the more light it can let in, and the lower the light level that is required to create acceptable shots.

light-fastness

The ability of a photograph or photo-realistic print to withstand light without major damage over time.

lossless/lossy compression

(*See* compression.)

loupe

A small magnifying device used to evaluate print quality of photographs, photo-realistic prints and other printed material.

media cards

Removable storage devices used to transfer data from a digital camera to a computer.

megabyte (MB)

(1,048,576 bytes) Unit of measurement commonly used to describe the size (memory required to store) of digital images.

memory

Where a computer stores data.

Memory Stick

A removable media developed by Sony.

metering

Use of an in-camera or hand-held device to measure the amount of light falling on (incident metering) or reflected by (reflected metering) a scene or subject. This reading is used to calculate correct exposure.

mouse

Device used to move the computer's on-screen cursor.

MPEG

(Motion Picture Experts Group) A file format used for digital video.

multi-format scanners

Device used to convert multiple formats of traditional media (prints, slides, negatives, etc.) into digital images.

negative

When shooting print film in a traditional camera, the negative is the developed film itself, where black appears as white and white as black (colors are reversed).

NiCad batteries

(Nickel Cadmium) a common type of rechargeable battery, often used in traditional film cameras. Their discharge characteristics make them less ideal for digital cameras than NiMH batteries.

NiMH

(Nickel Metal Hydride) Rechargeable batteries with discharge characteristics providing better peak power discharge than NiCad rechargeables. This makes them better for digital cameras.

optical resolution

The number of dots (or pixels) per inch which can actually be "seen" by a scanner or digital camera.

output device

The final destination device for an image, such as printers and film recorders.

parallel interface

A data-transmission technique in which pieces of data travel alongside each other, each in their own wire. The most common connectivity option for digital printers.

PCMCIA

(Personal Computer Memory Card International Association) A removable media format found on many higher-end and professional digital cameras.

Photo CD

A proprietary CD format for scans from slides, transparencies and negatives. Standard file size for scans is 18MB. Scans are made from any selection of images after the film has been processed and returned.

photograph

A continuous-tone (not made of dots) image with an infinite array of colors.

photo-realistic print

An image created by the application of dots of ink or dye to a substrate.

PICT

A file format that can be used for up to 24-bit (16.7 million colors) images.

Picture CD

A proprietary CD format for scans from 35mm slides or negatives made while the film is at the lab for processing and returned with the prints/slides. Features lower-resolution scans than Photo CDs.

pixel

(Derived from "picture" and "element.") The smallest component piece of a digital photograph. Each pixel has a number value that determines its color or shade.

plug-ins

Software modules that add capabilities to imaging programs.

processing speed

The speed at which the CPU is able to process data.

RAM

(Random Access Memory) Computer's memory used for running programs.

raster art

Images constructed from individual pixels.

removable media

Storage devices used to transfer data from a digital camera to a computer.

resolution

The measure of the amount of information contained in a digital photograph. The higher the resolution (measured in dots per inch), the more information is contained and the more detailed the image will be. (*See also* optical resolution and digital resolution.)

RGB

(Red, Green, Blue) A color space designed to create all colors using three colors of light (red, green and blue). Used with monitors and film recorders, as well as many scanners.

RIP

(Raster Image Processing) A program used to prepare raster images for output.

serial interface

A data-transmission technique in which pieces of data travel single file. The most common connectivity option for modems.

SCSI

(Small Computer Systems Interface) A way of attaching peripheral devices (such as scanners and printers) to a computer through a set of shared cables.

shutter

A device that allows light to pass into the camera for a set amount of time.

shutter speed

The duration of time the shutter is open, allowing light to enter the camera through the lens.

single lens reflex

(SLR) A type of camera where a mirror is used to reflect light from the camera's single lens onto the viewing screen where images are composed.

16-bit color

The digital ability to display 64,000 colors. This is the color range of later standard VGA systems.

SmartMedia

A format of removable media used by many digital cameras.

software

Computer programs designed to perform one or more specific functions.

spot color

Two-color printing process, often using black plus one accent color (called the "spot color").

substrates

Term used for paper and other materials (such as overhead transparencies) onto which photo-realistic images are printed.

SVGA

(Super Video Graphic Adapter) A higher-resolution computer graphics sub-system capable of displaying 16.7 million colors.

TIF

(Tagged Image File Format) A file format that can be used for up to 24-bit (16.7 mil-

lion colors) images. Optional lossless compression is available (resulting in smaller file sizes with no loss of image quality).

transparency

A photographic medium (such as a negative or slide) where the image is revealed by light passing through it.

transparency scanner

A device used to create digital files from transparent media (such as negatives and slides).

24-bit color

The digital ability to display 16.7 million (2^{24}) colors. This is the color range of SVGA systems.

USB

(Universal Serial Bus) A way of attaching up to 128 peripheral devices (such as scanners and printers) to a computer. Promotes high-speed data transfer and easy recognition of peripheral devices by the computer.

vector art

Illustrations constructed from mathematical equations (points, angles, etc.) rather than pixels.

VGA

(Video Graphic Adapter) A standard resolution computer graphics sub-system capable of displaying up to 16.7 million colors.

video board

The sub-system used by a computer to process graphic information for display on the monitor.

viewfinder

A device on a camera used to frame and preview an image before making an exposure (taking a picture).

water-fastness

The ability of a photograph or photo-realistic print to withstand moisture without major damage. Inkjet prints are notoriously susceptible to water damage.

zoom lens

A camera lens with more than one possible focal length.

INDEX

Other Books from
Amherst Media™

Basic Scanning Guide For Photographers and Creative Types

Rob Sheppard

This how-to manual is an easy-to-read, hands on workbook that offers practical knowledge of scanning. It also includes excellent sections on the mechanics of scanning and scanner selection. $17.95 list, 8½x11, 96p, 80 photos, order no. 1708.

Photo Retouching with Adobe® Photoshop®

Gwen Lute

Designed for photographers, this manual teaches every phase of the process, from scanning to final output. Learn to restore damaged photos, correct imperfections, create realistic composite images and correct for dazzling color. $29.95 list, 8½x11, 120p, 60+ photos, order no. 1660.

Computer Photography Handbook

Rob Sheppard

Learn to make the most of your photographs using computer technology! From creating images with digital cameras, to scanning prints and negatives, to manipulating images, you'll learn all the basics of digital imaging. $29.95 list, 8½x11, 128p, 150+ photos, index, order no. 1560.

Telephoto Lens Photography

Rob Sheppard

A complete guide for telephoto lenses. Shows you how to take great wildlife photos, portraits, sports and action shots, travel pics, and much more! Features over 100 photographic examples. $17.95 list, 8½x11, 112p, b&w and color photos, index, glossary, appendices, order no. 1606.

Achieving the Ultimate Image

Ernst Wildi

Ernst Wildi teaches the techniques required to take world class, technically flawless photos. Features: exposure, metering, the Zone System, composition, evaluating an image, and more! $29.95 list, 8½x11, 128p, 120 b&w and color photos, index, order no. 1628.

Black & White Portrait Photography

Helen T. Boursier

Make money with b&w portrait photography. Learn from top b&w shooters! Studio and location techniques, with tips on preparing your subjects, selecting settings and wardrobe, lab techniques, and more! $29.95 list, 8½x11, 128p, 130+ photos, index, order no. 1626

Big Bucks Selling Your Photography, 2nd Edition

Cliff Hollenbeck

A completly updated photo business package. Includes starting up, getting pricing, creating successful portfolios and using the internet as a tool! Features setting financial, marketing and creative goals. Organize your business planning, bookkeeping, and taxes. $17.95 list, 8½x11, 144p, 30 charts and tables, b&w, order no. 1177.

Outdoor and Location Portrait Photography

Jeff Smith

Learn how to work with natural light, select locations, and make clients look their best. Step-by-step discussions and helpful illustrations teach you the techniques you need to shoot outdoor portraits like a pro! $29.95 list, 8½x11, 128p, 60+ b&w and color photos, index, order no. 1632.

Practical Manual of Captive Animal Photography

Michael Havelin

Learn the environmental and preservational advantages of photographing animals in captivity – as well as how to take dazzling, natural-looking photos of captive subjects (in zoos, preserves, aquariums, etc.). $29.95 list, 8½x11, 120p, 100 photos, order no. 1683.

Photographing Children in Black & White

Helen T. Boursier

Learn the techniques professionals use to capture classic portraits of children (of all ages) in black & white. Discover posing, shooting, lighting and marketing techniques for black & white portraiture in the studio or on location. $29.95 list, 8½x11, 128p, 100 photos, order no. 1676.

Family Portrait Photography

Helen Boursier

Learn from professionals how to operate a successful portrait studio. Includes: marketing family portraits, advertising, working with clients, posing, lighting, and selection of equipment. Includes images from a variety of top portrait shooters. $29.95 list, 8½x11, 120p, 123 photos, index, order no. 1629.

The Art of Infrared Photography, 4th Edition

Joe Paduano

A practical guide to the art of infrared photography. Tells what to expect and how to control results. Includes: anticipating effects, color infrared, digital infrared, using filters, focusing, developing, printing, handcoloring, toning, and more! $29.95 list, 8½x11, 112p, 70 photos, order no. 1052

Camcorder Tricks and Special Effects, *revised*

Michael Stavros

Kids and adults can create home videos and mini-masterpieces that audiences will love! Use materials from around the house to simulate an inferno, make subjects transform, create exotic locations, and more. Works with any camcorder. $17.95 list, 8½x11, 80p, 40 photos, order no. 1482.

The Art of Portrait Photography

Michael Grecco

Michael Grecco reveals the secrets behind his dramatic portraits which have appeared in magazines such as *Rolling Stone* and *Entertainment Weekly*. Includes: lighting, posing, creative development, and more! $29.95 list, 8½x11, 128p, 60 photos, order no. 1651.

Essential Skills for Nature Photography

Cub Kahn

Learn all the skills you need to capture landscapes, animals, flowers and the entire natural world on film. Includes: selecting equipment, choosing locations, evaluating compositions, filters, and much more! $29.95 list, 8½x11, 128p, 60 photos, order no. 1652.

Photographer's Guide to Polaroid Transfer

Christopher Grey

Step-by-step instructions make it easy to master Polaroid transfer and emulsion lift-off techniques and add new dimensions to your photographic imaging. Fully illustrated every step of the way to ensure good results the very first time! $29.95 list, 8½x11, 128p, 50 photos, order no. 1653.

Handcoloring Photographs Step-by-Step

Sandra Laird & Carey Chambers

Learn to handcolor photographs step-by-step with the new standard in handcoloring reference books. Covers a variety of coloring media and techniques with plenty of colorful photographic examples. $29.95 list, 8½x11, 112p, 100+ color and b&w photos, order no. 1543.

Special Effects Photography Handbook

Elinor Stecker-Orel

Create magic on film with special effects! Little or no additional equipment required, use things you probably have around the house. Step-by-step instructions guide you through each effect. $29.95 list, 8½x11, 112p, 80+ color and b&w photos, index, glossary, order no. 1614.

McBroom's Camera Bluebook, 6th Edition

Mike McBroom

Comprehensive and fully illustrated, with price information on: 35mm, digital, APS, underwater, medium & large format cameras, exposure meters, strobes and accessories. Pricing info based on equipment condition. A must for any camera buyer, dealer, or collector! $29.95 list, 8½x11, 336p, 275+ photos, order no. 1553.

More Photo Books Are Available

Write or fax for a *FREE* catalog:

AMHERST MEDIA
PO BOX 586
AMHERST, NY 14226 USA

Fax: 716-874-4508

www.AmherstMedia.com

Ordering & Sales Information:

INDIVIDUALS: If possible, purchase books from an Amherst Media retailer. Write to us for the dealer nearest you. To order direct, send a check or money order with a note listing the books you want and your shipping address. U.S. & overseas freight charges are $3.50 first book and $1.00 for each additional book. Visa and Master Card accepted. New York state residents add 8% sales tax.

DEALERS, DISTRIBUTORS & COLLEGES: Write, call or fax to place orders. For price information, contact Amherst Media or an Amherst Media sales representative. Net 30 days.

All prices, publication dates, and specifications are subject to change without notice.

Prices are in U.S. dollars. Payment in U.S. funds only.

CUT ALONG DOTTED LINE ✄

AMHERST MEDIA'S CUSTOMER REGISTRATION FORM

Please fill out this sheet and send or fax to receive free information about future publications from Amherst Media.

CUSTOMER INFORMATION

DATE

NAME

STREET OR BOX #

CITY STATE

ZIP CODE

PHONE ()

OPTIONAL INFORMATION

I BOUGHT *Basic Digital Photography* BECAUSE

I FOUND THESE CHAPTERS TO BE MOST USEFUL

I PURCHASED THE BOOK FROM

City State

I WOULD LIKE TO SEE MORE BOOKS ABOUT

I PURCHASE BOOKS PER YEAR

ADDITIONAL COMMENTS

FAX to: 1-800-622-3298

if mailing, fold in number order along dashed lines.

Name_____
Address_____
City_____State_____
Zip_____ — _____

Place
Postage
Here

Amherst Media, Inc.
PO Box 586
Amherst, NY 14226

if mailing, paste underside of flap, or tape here.